MAKING JAPANESE
WOODBLOCK PRINTS

MAKING JAPANESE WOODBLOCK PRINTS

Laura Boswell

THE CROWOOD PRESS

First published in 2019 by
The Crowood Press Ltd
Ramsbury, Marlborough
Wiltshire SN8 2HR

enquiries@crowood.com

www.crowood.com

This impression 2021

British Library Cataloguing-in-Publication Data
A catalogue record for this book is available from the British Library.

ISBN 978 1 78500 655 5

Photographs by Ben Boswell

This book is dedicated to the memory of Keiko Kadota

Typeset by Kelly-Anne Levey
Printed and bound in India by Replika Press Pvt Ltd

CONTENTS

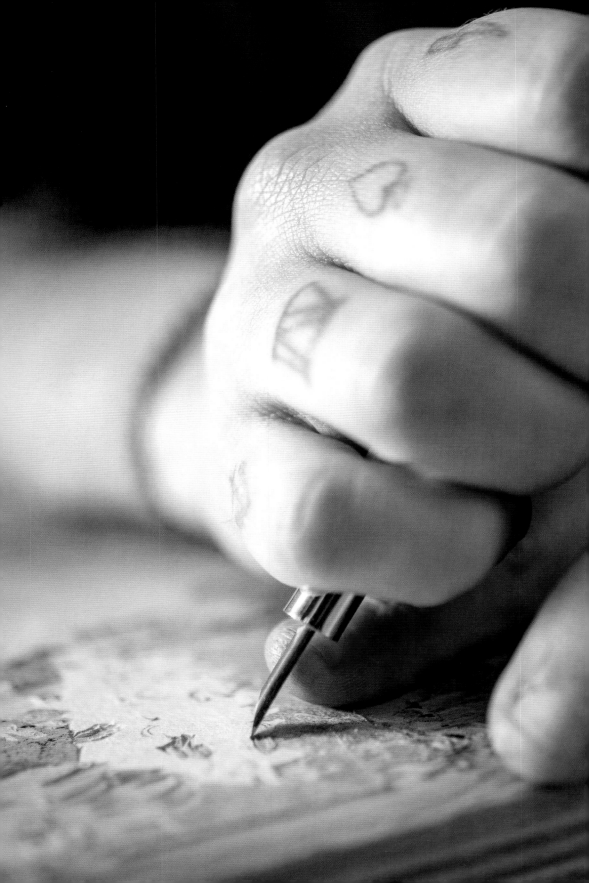

INTRODUCTION

The art of Japanese woodblock printing is growing in popularity among Western printmakers and rightly so; it is a flexible and non-toxic printing method that requires little space and no printing press. Materials and tools are becoming increasingly available and the medium is adaptable, allowing Western materials and tools to be substituted where Japanese versions are hard to find.

Japanese woodblock has a unique system of registration, cutting and printing. It often goes by the name *mokuhanga* (wood print). Woodblocks are carved with their registration cut into the wood alongside each block, while printing relies on brushes and water-based paints combined with rice paste, rather than inks and a roller. The built-in registration and brush printing makes for a thrifty approach, allowing the printmaker to fit multiple blocks on one sheet of wood. The multi-block process means the woodblocks are available to print as many times, and in as many ways, as the printmaker wishes.

How to Use This Book

This book is very much designed as a practical introduction to Japanese woodblock printing. It will take you through the process, step by step, from design drawing to finished print. Chapters 1 to 6 take you from drawing to basic printing, each chapter finishing with a list of goals that should have been achieved so that you can confirm that you are ready to progress. The later chapters detail more advanced printing and carving techniques plus advice on editioning your prints and their aftercare, tool care and sharpening.

The technique outlined on these pages is a contemporary and accessible approach, using a tracing paper transfer method to take your design from drawing to woodblock, rather than the traditional cutting of a key block and use of transfer prints outlined in this introduction. You will be using the traditional systems of registration, cutting and printing that define an authentic Japanese woodblock.

A Mindful Approach

It seems strange to advise on the correct mindset for a print process, but I cannot emphasize enough how much more smoothly your work will progress if you adopt a calm, patient and organized approach. Japanese woodblock is a

OPPOSITE PAGE: **Woodblock carver Will Francis carves a block of cherry ply.**

method with no hard rules; rather it requires you to gain a feel for the balance of your materials and the movement of your tools, developing your skill and fluency through practice over time. If you can learn to relish working in a tidy, logical way with calm and focused attention, you will find the learning process itself rewarding, almost meditative, and you will avoid the simple mistakes that happen through rushing or working in a muddle.

Brief History of Japanese Woodblock

Origins

Woodblock printing arrived in Japan from China in the eighth century CE along with the art of papermaking. Japan's climate and timber, combined with the potential that the Japanese saw in woodblock as a means of mass printing, elevated woodblock printing into a flourishing industry in its own right. Over time, woodblock printing became a sophisticated and respected art employing many artists, along with workshops of skilled carvers and printers, reaching its peak during the Edo period (1603–1868). Monochrome works, originally printed entirely in black *sumi* ink, became coloured, at first by hand and later with additional colour blocks. It was the need for a fast, accurate method for printing in colour that led to the development of the *kento* registration system that you will also learn to use.

By the mid-1700s, colour art prints were becoming increasingly rich and complex. There was a ready market in Japan's wealthy merchant classes who, denied the more rarefied art forms of the aristocracy, embraced woodblock prints as their own. Woodblock prints from this time are known by the name

of *Ukiyo-e*. This translates as 'pictures of the floating world' and has its origins in a Buddhist concept of a transitory and changeable sensual world. These are the prints that were to have a major influence on nineteenth-century Western artists, captivated by the woodblocks' linear, flat appearance, exotic subject matter and asymmetric composition.

Print Production during the Edo Period

Woodblock was the sole means of mass printing during the Edo period in Japan and encompassed everything from artistic prints to sweet wrappers. It was a time of intense competition and demand for all kinds of woodblock printing with *eshi* (best defined as men doing the work of graphic designers and illustrators) working alongside the *gaka* (fine artists). Boundaries between eshi and gaka were not always clearly defined and some men fulfilled both roles. At this time woodblock printing was a combined effort, involving the work of a publisher, artist, carvers and printers. The publisher was in control of the process, sourcing clients, financing the work and owning copyright. He either found commissions for work that could be produced by eshi, or sought patrons for the particular talents of gaka such as Utagawa (Andou) Hiroshige or Katushika Hokusai.

Once the publisher had work, he commissioned the eshi or gaka to produce a detailed brush drawing onto thin paper called a *hanshita*. This was taken to the *horishi*, master carver, who would paste the drawing face down onto cherry wood and cut the 'key block' (sometimes known as the 'line block' since it reproduced all the outline details needed to define the coloured areas of the print). Details such as repeating prints on fabric or the individual hairs of hairlines were often left for the horishi to interpret and

complete. Several monochrome copies, called *kyogo*, would be taken from the key block. These were returned to the artist who would add samples of the colours required, along with marking up the appropriate position for each colour. Once the colour samples were supplied, the artist's involvement with the work was finished and the craftsmen took over. Marked-up kyogo were pasted to cherry wood as guides for carvers who cut the colour blocks to accompany the key block. Once the blocks were finished, the printers produced as many prints as the market demanded. Prints were often produced in great numbers and, with the exception of fine quality prints made specifically for collection, sold relatively cheaply. There was no concept of the artist printmaker, creating a limited edition print from start to finish, as there is today.

Shin-hanga (New Print)

This twentieth-century print movement is largely attributed to the publisher Shōzaburō Watanabe, though other publishers were involved. The movement still worked within the traditional roles of the Edo period with publisher and artist relying on the expertise of the carving and print workshops, but the resulting prints reflected a far greater freedom and diversity of expression than Ukiyo-e prints, with modern themes often reflecting the influence of Western art. Although the movement died out in the 1960s, there are still artists who work with master carvers and printers in this way. Mokuhankan, a carving and printing workshop based in Tokyo established and run by David Bull, is a good example of this practice. Bull collaborates with artists, notably Jed Henry, to produce modern prints that meet the exacting standards of traditional Edo period works.

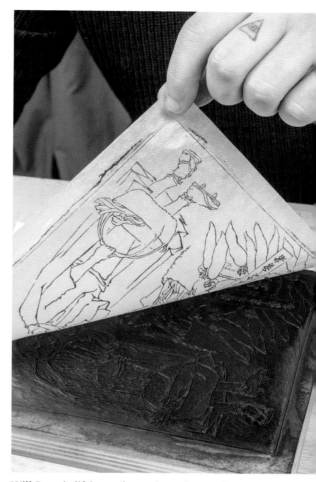

Will Francis lifting a 'kyogo', a print made on gampi tissue, from his key block. This kyogo will be marked up for colour and then stuck face down on a fresh wood block to act as a guide for cutting the colour blocks.

A set of cherry blocks cut using traditional methods for the print *A Frugal Hero* (designed by Jed Henry and cut by Will Francis).

Sōsaku-hanga (Creative Print)

The concept of the artist printmaker, creating the artwork, blocks and final prints, appeared in Japan in the early twentieth century, along with increasing interest in individual expression and concepts surrounding modernity. The artists who embraced the process often needed additional work to make a living, such as carving or illustration, and consequently there was something of an overlap between sōsaku-hanga and the shin-hanga movement.

The advent of World War Two brought difficulty and hardship for Japanese printmakers along with a scarcity of supplies. However, sōsaku-hanga and shin-hanga prints were to play a pivotal part in the post-war regeneration of Japan. The popularity of prints as souvenirs among the occupying American forces, along with the support and interest of influential American connoisseurs, created both a market in Japan and a place on the world stage for shin-hanga and sōsaku-hanga work. Sōsaku-hanga prints continued to grow in popularity and influence, winning prizes in the West, notably at the São Paulo Biennial in 1951, Japan's first post-war participation in an international exhibition.

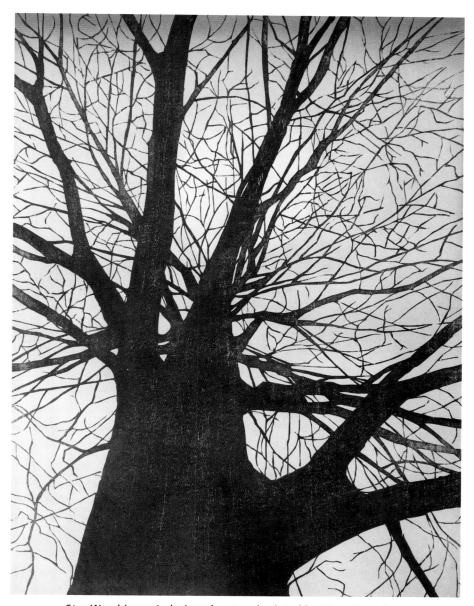

Star Worshipper 1, **designed, cut and printed by Mara Cozzolino.**

Towards the end of the twentieth century, interest had moved on in Japan, with printmakers embracing Western techniques and oil-based printmaking, while a few traditional workshops remained, producing copies of Ukiyo-e prints. Today, the outlook is much brighter, with a revival of respect for this adaptable technique along with an appreciation for the skills involved and for the remaining experts in the technique. Classes in Japanese woodblock printing are growing in number both in Japan and across the world.

DRAWING AND DESIGNING THE PRINT

Japanese woodblock printing is a 'multi-block' process. This simply means that to arrive at your finished print, you will be designing, cutting and printing a set of several blocks. These will fit together to complete your picture. This chapter deals with the process of developing your ideas, turning them into sketches and refining your sketches into a finished design drawing, ready for transfer onto your wood for cutting. It explains how to plan an appropriately simple image for a starter print, including understanding of how an image is broken into the various blocks needed to make a print, plus the various ways you can divide up your design to create blocks that print to best effect.

Inspiration

Historic Japanese woodblock prints have such a strong visual identity that it is tempting to think that the medium is best suited to a few traditional themes. However, if you dig a little deeper you will find Japanese woodblock prints depicting any number of subjects and ideas with a rich and varied approach. In a medium that is suited to everything from the most delicate observational studies to bold abstracts, there is

no need to limit your ideas. Bear in mind that your personal tastes, interests and preferences will make for the most satisfying prints both to create and to view. In addition, by following your own ideas, your prints will develop a strong and individual identity.

Get into the habit of jotting down ideas and sketches, saving clippings or taking photos whenever and wherever you see possibilities for a print. Inspiration often comes from unexpected places and it could be a scrap of fabric or the photo you snapped from the bus that proves to be the start of a great print. Take a magpie approach to your collecting and scoop up anything that you find of interest.

Allow time for ideas to develop and don't be too hasty to throw anything away, especially not your sketches. You should never be judgemental about the quality of your drawing when jotting down ideas; remember you are taking notes, not creating a masterpiece. Review your visual collection regularly and ask yourself why you chose to keep these particular visual cues and how they might work in a print. Always jot down any print ideas in notes or a thumbnail sketch as they arise. You may not be able to turn your inspiration into a print immediately, but you will have moved towards your goal by developing and recording your thoughts.

OPPOSITE PAGE: **Developing a sketch for later use.**

Always be on the lookout for inspiration and keep a visual record of your findings, jotting down ideas as they occur.

Elements of Design

Printmaking is very different from drawing and painting. It is process-led, meaning you must design, cut blocks and print to arrive at your desired image, rather than make an immediate impact with a brush or pencil. This means your Japanese woodblock prints will require a different and more graphic visual language, especially in the early days. While there are certainly plenty of traditional prints that could pass for watercolour paintings, it is worth remembering that they are the products of expert specialists with many years of experience. Better to be bold and simple in your ideas when learning your craft. Here are a few suggestions taken from the Japanese woodblock tradition for ways of making a simple design interesting.

- Scale: do not be afraid to make your main subject rather larger in a print than you might in a painting. This boldness will give your print strength and, on a practical note, your blocks will be easier to cut accurately and well. This may mean cropping your subject at the edges of the print, but this is often a positive step and makes for a much more visually exciting print.

- Composition: experiment with unexpected compositions. Try moving your horizon until it is very high or very low. Play with moving your main subject to the far edges of your print, or try obscuring part of it with something large in the foreground. These unexpected proportions and juxtapositions challenge the viewer and turn a simple print into something more sophisticated.

- Empty space: never be afraid to embrace areas of empty space in your print. This could be a simple block of colour, or even areas using the unprinted paper surface as part of the design. By having areas of detail balanced against areas of quiet space, your print will be visually interesting. Designing a print that carries the same level of visual detail and information from edge to edge with success is a tricky challenge.

- Simplify: catching every detail of your subject would make for an admirably skilled print, but not necessarily a successful one. Part of the beauty of Japanese woodblock printmaking is learning how to simplify objects and shapes to catch their essence. When you are simplifying, look at the overall shape of the subject and

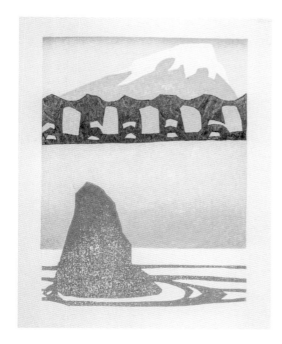

the negative space around it, rather than the details of the subject itself. If you get these two basics right, very little detail is needed for your audience to read and appreciate your print.

Where to Begin

Before you take your ideas and sketches and turn them into a design for your Japanese woodblock print, there are some practicalities to consider. If you make a few decisions before you start, it will help to make the whole process easier to control and follow.

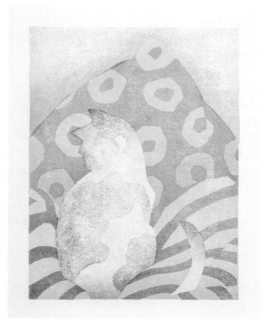

Measurements

Throughout this book, when following the sequence of actions, please use either metric or imperial measurements consistently. Do not mix them as they do not convert exactly.

These three prints will appear as examples throughout this book and follow the elements of design detailed here. The print area is 15cm × 20cm with a 2cm margin area (6in × 8in with a ¾in margin). All examples are printed on Fabriano Academia HP 200gsm.

EQUIPMENT AND MATERIALS LIST

Detailed descriptions of tools and materials and how to choose and care for them are included in the chapters that explain their use. There is a list of suppliers at the end of the book.

Cutting
Chisel for cutting kentos
Hangi-to cutting knife (right- or left-handed)
Tools for clearing wood: U gouges and chisels
V tools for creative cutting
Shina ply woodblocks (sometimes called Japanese or Asian ply)
Non-slip mat or bench hook
Waterproof wood glue

Printing
Baren for taking the print impression
Brush for wetting paper (also for sizing paper)
Cheap brushes for mixing paints
Printing brushes
Rice flour to make rice paste (*nori*) (or ready-made nori can be used if preferred)
Paints in tubes, watercolour or gouache
Sumi ink
Chopsticks

Papers
Drawing paper
Tracing paper
Carbon paper
Printing paper
Proofing paper
Blank newsprint
Baking parchment
Newspaper or blotting paper to make a damp pack

Sundries
Cotton rags (old towels are excellent)
Masking tape
Pots or bowls for paint and nori
Pencils, eraser, ruler and set square
Camellia oil
Fine sandpaper or fine sanding block
Box cutter or *kiridashi* for cutting paper
Water bottle (a plastic safety wash bottle with a curved spout works best)
Plastic sheeting for making a damp pack
Leather strop and honing paste for stropping tools

Water-stones, diamond-stones or lapping film for sharpening tools

Extras for Further Techniques
Blowtorch
Wire brush
Animal glue/vegetable gelatine and alum for sizing paper
Mylar sheets or thin card for cutting stencils
Gum arabic
Mica powder
Thin paper for brush painting (layout paper, airmail paper or thin washi paper)

Safety
You will be using sharp tools. In your workplace it is therefore essential to have a first aid kit that is clearly marked, easy to reach, and up to date with the right sorts of dressing. Add a large label with emergency contact numbers.

A selection of traditional painting brushes.

Working Out the Size of Your Print

Your Japanese print consists of two areas and you will need to decide on the sizes of both when creating your design drawing. The first area is the space occupied by the printed image, here called the 'design area'. The second area is the margin of unprinted paper that runs right around your print. Because of the registration system used to line up your various blocks with each other for accurate printing, the margin is an essential part of the print.

- Choosing the design area size. While making your first prints, it is best to keep your work fairly small. I would suggest making the size of your design area no bigger than about 25cm × 25cm (10in × 10in). You will have enough space to experiment, while cutting and printing the blocks will not pose an overwhelming task. In Chapter 8 there is advice about working on

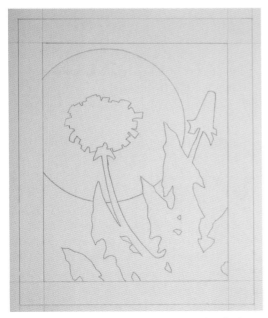

A finished design drawing showing the design area and the margin area.

large prints, as this brings its own challenges, demanding confidence plus some experience to achieve success.

- Choosing the margin size. With the size of print suggested here, a margin size of 2cm (1in) will work well. This margin size will allow you to hold the paper and position it with less chance of marks in the margin. Traditional Japanese prints often have extremely small margins, but they were printed by experts and the Western tradition of numbering and signing prints in the margin was not used at the time. Don't be too tempted to go much wider with your margin size either; an over-wide margin will increase your paper size for no benefit and the overall print will become harder to handle.

Fixing the Final Size of Your Print

Option 1

Make a decision and choose your print size before you begin drawing, making a fixed-sized template to accommodate your design. This option has advantages if you have a specific size of paper or frame to fill. Alternatively, it can be important if you are working on a series or set of matching prints, or if you are setting yourself a challenge to work with a specific size format.

1. Choose the size of your design area and the size of your margin.
2. Take paper large enough to accommodate both your design area plus the margin.
3. Draw a box the size of your design area.
4. Measure your margin around the design area and draw a second box around the first, so that you have both the design area and the margin area marked on your paper ready to accommodate your design.
5. You may like to mark up several pieces of paper this way. Alternatively, mark one up with bold lines that you can use to slip under

blank paper to act as a guide while you are testing out your design.

Option 2

Take a more flexible approach and choose a rough size for your design drawing, cropping or adding to the dimensions of the print as you go.

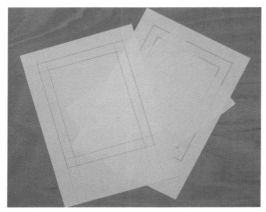

A pre-drawn template with a fixed-sized area for the print design and its surrounding margin, either for use directly or as a guide under blank paper.

A flexible approach allows for changing the shape of this sketch to its final dimensions, plus margin, as the design is finalized.

This option has the advantage of allowing you the freedom to change your composition and dimensions at will to benefit your design.

1. Decide roughly what your design area will be and make a choice about your margin size. The margin size can also be flexible at this stage if you wish.
2. Choose paper large enough to accommodate your design, allowing reasonable space for changing the dimensions of the design as you go. Remember to allow for the essential margin width to go around the design area once it is decided.
3. Draw a box for your design area in a pale colour as a guide and make your drawing, cropping, adding or changing the dimensions as your image develops. You can ignore the guide frame at this stage.
4. When the design drawing is finished and your final dimensions are decided, draw a bold outline tight around your design. Don't forget that if you include white space as part of your design drawing, it also needs to lie within this frame.
5. Measure the area needed to accommodate your margin space around the newly drawn outline of your design area and draw a second frame to mark the margin area.

Managing the Complexity of Your Print

Some teachers suggest that your first print should consist of one or perhaps two basic shapes to enable you to grasp the principles of cutting and printing before you make a picture. In reality, working on a simple figurative or abstract design is more likely to hold your interest and encourage you to persist with your first experiments.

Before you have experience of making a Japanese woodblock print, it is hard to understand how to make a successful first design that is both simple enough to work with and interesting enough to enjoy cutting and printing. Here is an exercise for making this chicken and egg situation a little easier.

Begin by looking at a selection of traditional Japanese woodblock prints. If you look closely you will start to notice that they consist of soft blends and bleeds of colour in some places (the sky in landscapes is usually the most obvious example), while in other areas the colours are crisply divided with hard edges. *Chiltern Seasons, Autumn* demonstrates this.

- Where the colours change in a soft blend or bleed from dark to light, the effect is achieved by inking up the same single block, often repeatedly, rather than by using a set of different blocks.
- Where colours are crisply divided with hard edges, different blocks are needed to create this effect. Every sharply defined shape requires a separate block to give it a crisp outline.

With this in mind, challenge yourself to work out how many blocks are needed for each print, trying to imagine where you could and couldn't get away with fewer blocks and still have a good print.

Designing a print that uses four or five blocks at the most, simple in shape, is the best way to begin. This simplicity will enable you to cut and print in a short enough time not to lose heart. Until you have learned the skills of cutting and printing, anything more ambitious is likely to become a frustration rather than a pleasure; taking overlong to cut and print and, as a first try, will almost certainly be doomed to disappoint. A simple approach to your first few prints will allow you to concentrate on the process, rather than on your high ambitions for the finished image. These prints' very simplicity will make your chances of early success much more likely.

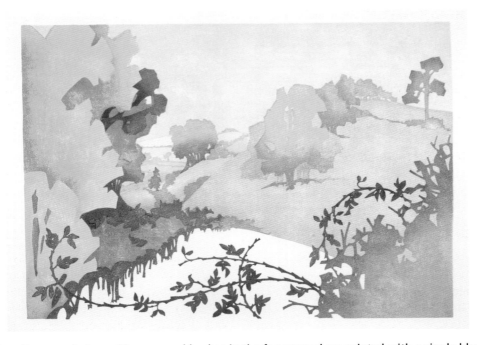

Chiltern Seasons, Autumn. **The rose and bushes in the foreground are printed with a single block defining different areas with soft changes of colour. In contrast, the individual trees throughout the print are separated by sharp outlines created by printing a different block for each tree.**

Initial sketching-in of shapes and ideas. Aim at finishing with four or five simple shapes for a starter print. Plan how many blocks are needed by remembering soft colour changes use one block, crisply edged colour changes need separate blocks.

Refining the sketch into stronger outlines, defining each shape. The next section of text will describe how overlaps can work in your design, when to use them and how they will affect your finished print.

Editing Your Sketch into a Design Drawing

Editing from sketch into design drawing is essential to making a successful print. Sketches are an impulsive way of working; they are quick and immediate, often suggesting objects rather than outlining them with shading and textural lines. Change your sketch into a design drawing by clarifying all outlines. The design drawing is the blueprint for your blocks, mapping where the edges to be cut will lie. The design drawing needs to show your drawing in clear linear outline only.

This example shows the journey from sketch to design drawing, using a pre-decided size for the design area and margin as previously described.

Final outlines are defined, along with areas where blocks will overlap, resulting in a finished design drawing. Colour your design drawings for clarity if needed.

Breaking the Design Drawing into Blocks

Essential Note on Printing with Watercolour Paint

Watercolour paint is a largely transparent medium. It is impossible to print a block inked in pale watercolour over an area inked in dark watercolour and expect the pale colour to show as a defined pale shape. It is important to remember this when you are dividing your design drawing into its separate blocks.

This section shows how various simple design drawings can be broken into their various blocks in different ways. Here, block A is coloured yellow, block B is coloured blue, overlaps are shown in green.

RIGHT: **In these examples, the over-printed pattern disappears into the background colour when printed in a paler colour, but shows clearly when over-printed in a darker colour than the background.**

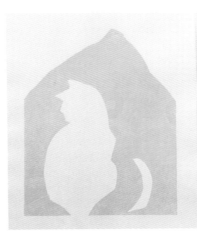

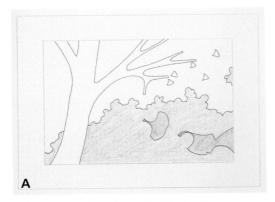

A

B

Using no overlaps: here the blocks all fit together like a jigsaw with nothing overlapping. This way of working demands the most accurate cutting, as the edges of every block must fit neatly to the others, but it gives the most flexibility when printing because no block lies over another. This allows you to print each block light or dark at will.

Overlapping a feature block: here the feature block (B) overlaps the background blocks. This allows you to avoid the more demanding task of cutting away space in the background blocks to accommodate the more detailed block accurately. However, this means the feature block must always be printed in a darker tone or colour than the background blocks, in order for it to show in the finished print.

C

D

Overlapping blocks to add detail to the image: in this design, one block (A) is extended to run under another block (B). By doing this, any details cut in block B will allow the colour of block A to show through. This both adds interest and allows fine detail to be cut into block B without the need for planning or fiddly registration. To reveal this technique to best effect there will need to be a good contrast between the two blocks when printing. Remember that, should you print them in different colours rather than different tones, both colours will combine: for example block B printed in blue over block A printed in yellow is likely to result in a green print with yellow details.

Overlapping blocks for dramatic effect: this is useful in situations where subjects are naturally transparent, or in abstract prints where you want to exploit the transparency of your colour layers to effect a colour change.

This is a 'white line' or Provincetown print: it uses cut lines in the block to divide up the colours when printed. This printing method developed in the USA in the early twentieth century to mimic Japanese woodblock printing.

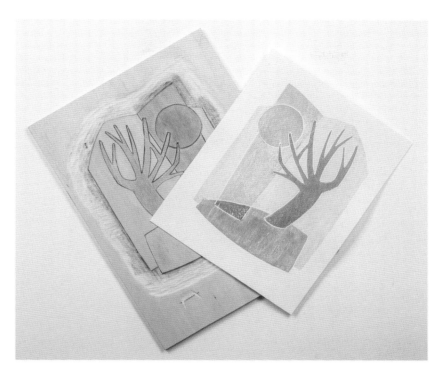

Creating the Suggestion of Multiple Blocks using a Single Block

There is a simple and very effective way of mimicking the crisp edges of multiple blocks in your print while only using a single block, but it does come at a price. To achieve this effect, you must cut a thin line through your block's surface to mimic a hard edge. You can then use that cut line to define the separate areas of the block when inking. This can save a lot of effort, but the finished print will show the cut line dividing the areas of your print, rather than showing colours meeting seamlessly. In addition, you will need to be very precise when inking up the different areas of the block.

Goals for This Chapter

By the end of this chapter you will have gone from finding inspiration to a simple finished design drawing, ready to trace and transfer to your wood for cutting.

- Your finished design drawing will have complete clear outlines around every part of the drawing.
- You will be able to break up your design drawing up into the four or five simple sections that will become your various woodblocks for printing.
- You will have decided if any of these blocks will overlap with each other or not.
- Your finished design drawing will have a line around its edge defining the design area. Around the design area will be a larger outline defining the space of your margin area.

TRANSFERRING THE DESIGN DRAWING ONTO THE WOOD

The Master Tracing

In this chapter you will be transferring your design drawing onto your wood ready for cutting your woodblocks. You will be using tracing and carbon paper for the task.

Making a master tracing is key to this method of making a Japanese woodblock. The task of the master tracing is to transfer all the information of your design drawing onto your wood, plus the information needed for you to mark out your registration system for aligning your blocks.

- The master tracing gives you a very accurate way of dividing your design drawing into its various blocks and then transferring those blocks onto your wood, ready for your cutting.
- To have your print appear in the same orientation as your drawing, rather than as a mirror image, you need to reverse your drawing when it is applied to the wood. The master tracing will make this very simple.
- You need all your blocks to share a precise registration system for them to work together to make a finished print. Registration simply means the system that is used to line up the printing paper as it is moved from block to block as the picture is printed, allowing the different blocks to fit together accurately. In

Japanese woodblock the registration system is called 'kento'. Your master tracing will make marking out your kento registration both simple and accurate.
- As an additional benefit, your master tracing provides a means to change your print in the future. Because your registration is marked up using your master tracing, you can draw new elements onto your master tracing to add to or change your print. Then you can use the master tracing to create new blocks to add to your print, maintaining the correct registration.

Note on Accuracy

Accuracy is everything when you make a master tracing. If your master tracing is accurate, your registration and your blocks stand a good chance of being accurate too, even allowing for a bit of wobbly cutting. Conversely, if your master tracing and the transfer of its information to the wood are done without care, your print is very unlikely to align and work well however accurately you cut the blocks. It is very important that you follow all the steps below, especially the first instruction on positioning your tracing paper correctly.

OPPOSITE PAGE: **Placing the master tracing onto the wood to transfer the design.**

Making Your Master Tracing

Make sure that you have a piece of good-quality tracing paper or plastic tracing film large enough to accommodate both your design drawing and the margin frame around the design. Also, ensure that the tracing paper is cut with accurate right angles at the corners in order for it to line up with the carefully accurate right angles you made in your design drawing and its margin.

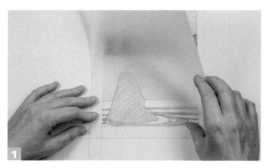

Place your tracing paper so that it lines up exactly with the *bottom left-hand corner of the outside frame of your master drawing*. This placement is vital: you will be using the edge of your master tracing to draw out your registration when you transfer the design to the wood. If you place the tracing paper in the wrong place, you will not have the accurate registration needed for making your print.

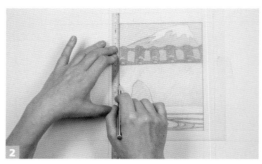

Make sure your tracing is held in position with masking tape. Take your ruler and draw round the inside frame using a sharp hard (2H or similar) pencil.

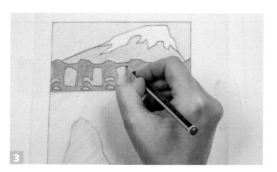

Trace your entire design drawing clearly and cleanly including all overlapping lines.

Once you have a completed tracing, flip it over so that the drawn side is now facing downwards ready to be traced over from the back. By flipping the tracing paper over, you have reversed the image. As long as you remember to keep it flipped over when transferring your image to the wood so that the tracing is face down, the finished print will be the same way round as your drawing, rather than a mirror image.

These kento marks, shown in red, will remind you to draw the lines needed as cutting guides for cutting your kento registration slots.

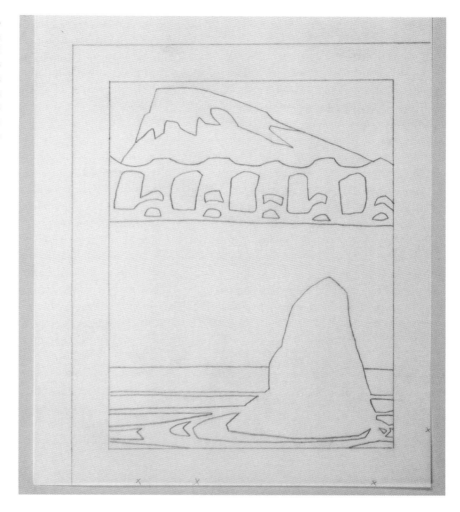

Marking Kento Registration Points on Your Master Tracing

In addition to allowing you to map out your various blocks, your master tracing also gives you the guide lines to map out and cut your registration marks so that all your blocks fit together accurately.

The Japanese kento registration system consists of two slots cut into the wood, acting as little shelves to prop the printing paper into to hold it in the correct place. One slot is L-shaped and is positioned at the bottom right-hand corner of your block. The other is a straight slot about three-quarters of the way along the bottom of your block.

The next chapter will explain more about kentos and how to cut them. For now, just make yourself two sets of 'kento marks' on your master tracing. Make one set 3cm (1¼in) from the right-hand corner on the base and the side of your tracing (remember your master tracing should be flipped over at this point). Make the other set 3cm (1¼in) apart at about three-quarters of the way along the bottom edge of your master tracing. You will be drawing lines between these kento marks to act as a guide for cutting when you map out your blocks.

Wood for Your Print

Japanese woodblock is very adaptable; you can work with almost any sort of ply or solid wood provided that the surface is porous and has not been sealed with paint or varnish. Historically, Japanese woodblocks were cut into solid cherry. In modern Japan, cherry ply is the wood of choice for traditional carving workshops and many artists. Shina plywood was introduced in Japan in the 1960s as an easy and economical alternative for artists who were looking to cut and print their own blocks, working with much shorter print runs than the traditional workshops. It is readily available and is the wood I use for nearly all my own work.

I strongly recommend starting with shina plywood. It is available from suppliers specializing in printmaking goods. You may find it called Japanese ply or Asian ply.

Shina plywood is an easy and rewarding wood for this technique and can be bought from most suppliers specializing in printmaking supplies.

It has the following benefits:

- It is a sheet material available in various standard sizes, including much larger sizes than solid wood. It has a uniform surface and will not warp or crack.
- Being ply, the wood is in layers and this will give you a good guide to cutting depth while you become comfortable with your cutting.
- It is smooth and soft, making it easy to cut. It will not show any wood grain when printed.
- Both sides of the wood can be used for Japanese woodblock printing. Both sides of the shina are the same and ready to be cut.
- It is an economical product. It comes at several price levels and the more you pay, the better the quality. The cheapest grades will come with occasional seams in the wood, the wood layers will be thinner and the glue less durable than the more expensive grades (often referred to as 'professional' grades). Cheaper grades are best used for experimentation and the simple uncomplicated shapes of an early print. It is best to move on to better grades of shina as your skills improve and your prints become more precious.

Preparing Your Wood

Shina ply comes ready to use, but you may like to work the wood over gently with a fine sandpaper to give it a super-smooth finish. You can stain the wood to make it easier to see your cutting if you wish. To stain the wood, make a dilute mix of watercolour paint, nothing too dark or strong, brush it over the wood and leave to dry. Before you print, wash your block gently with water to remove any likelihood of the stain affecting the colour of your printing.

Dos and Don'ts for Planning Your Layout

In these photos, the blocks being discussed are coloured red on the master tracing.

Check carefully to see if there are any seams in your plywood. Cheaper grades of shina ply can have seams. If you find one, make sure that you avoid putting a block across the seam. It's fine to cut a kento across a seam, but your block will be constantly wet while you print. The seam can absorb water and give an uneven print or can cause the block to chip or to delaminate while printing.

You must ensure that there is space both for your block and for your kento slots. This means checking you have space to draw the guide lines joining up your kento marks on the outside edges of your master tracing as well as the block in question. These kento guide lines need to be at least 1cm (½in) away from the edge of the wood to prevent the ply from splitting when you cut your kentos.

Always check to see if you can map out more than one block without having to reposition your master tracing. Having more than one block with the same kento will save you space and helps to keep your registration accurate. To begin with, only do this if blocks have a gap of at least 2cm (¾in) between them; any closer will make printing fiddly.

Dos and Don'ts for Planning Your Layout (cont'd)

Blocks can be placed right up to the edge of your wood, saving time with cutting. If you are using the edge of your wood as the edge of your block, ensure it is smooth and straight before you map out your block. Your blocks can be positioned anywhere on your wood provided there is space for the block and its kento, and as long as neither the block or kento you are mapping comes too close or overlaps with any other block or kento already mapped out. This means you can be economical with your layout, positioning more than one block on one side of your wood where possible. Remember that you can use both sides of the wood for your blocks.

It is essential to draw a clean outline around your block when using the master tracing, as this will be your cutting guide. You must follow the lines you have drawn on your master tracing exactly when mapping out your set of blocks. If you vary your outlines between blocks, your blocks will not match up in the finished print.

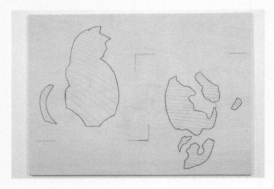

When mapping out your block, only map out the block in question, not the entire design drawing. Only draw in additional blocks if they are going on the same kento. Carbon and pencil marks on your wood will not transfer to your paper when you come to print, so feel free to shade in your blocks to make choosing where to cut easier, or to number your print and its kento to help you remember what goes where.

When mapping out your block, you may like to draw guide lines onto the block, not for cutting but to show you where to place shadings when you come to print.

Every time you move your tracing paper on the wood to map out a new block, you must also remember to draw your kento guide lines between your kento marks. If you forget you will have no registration for your new block when it comes to printing.

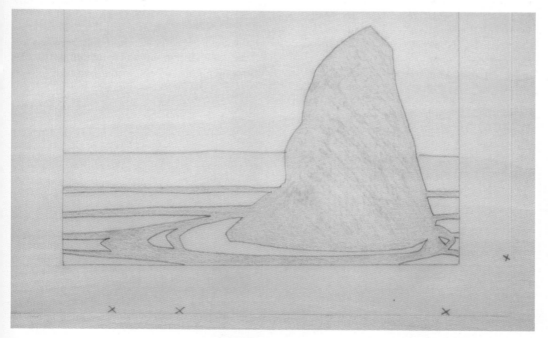

If you have a block that consists of long thin shapes, try to orientate your tracing so that the length of the block runs in the direction of the grain, as this will help to keep the block intact.

Preparing to Use Your Master Tracing

In the previous chapter you learned how to divide your design drawing into the various blocks needed to make your finished print. By this stage, you should understand how your design drawing breaks down into blocks and if any of these blocks need to overlap. The master tracing is your guide to get your various blocks mapped out onto the plywood along with their kento registration marks ready for cutting. You will need:

- masking tape strong enough to hold the tracing in place while you transfer your drawing
- carbon paper
- a sharp hard pencil
- a ruler for any straight edges.

Mapping Out Your Blocks

1. Choose which block you want to map out first. I usually start with the largest.
2. Take your master tracing and lay it face down on the wood in your chosen position, following the 'Dos and Don'ts' about layout.
3. Tape the tracing firmly to the wood leaving a space open, so that you can slide your carbon paper into place later without moving the master tracing.
4. Mark out your kento guide lines using the advice below.
5. Once your two kentos are marked, slide your carbon paper, transfer side down, onto the wood under the master tracing without moving the tracing.
6. Using your pencil, draw out your chosen block, remembering to draw round the block's entire shape.
7. If you have another block to map out onto the same kento, draw that one in too.
8. Remove your master tracing and move it into a new position to map out the next block in the same way. Continue, using both sides of the wood and moving onto additional blocks, until your entire print is mapped out.

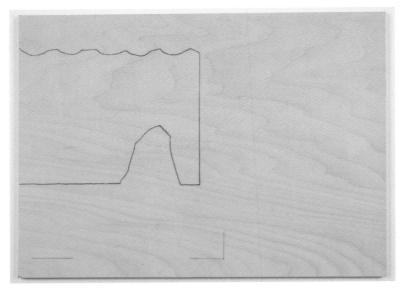

Once mapped out, your block and its kento guide lines should look like this.

MARKING OUT YOUR KENTO REGISTRATION

Try to get into the habit of doing this before you map out the block to avoid forgetting.

- Using a sharp pencil (HB or softer) and, holding the edge of your master tracing in place, draw the guide lines for your kento registration slots, running your pencil carefully and accurately along the edge of your master tracing between each of your two sets of kento marks.

- It is essential that you do not move the tracing paper at all until the block corresponding to these guide lines is also mapped out. If the master tracing is moved during this the kento will no longer match its block.

Take your time to run your pencil carefully along the edge of your tracing paper so the kento guide lines remain consistent for every block.

Goals for This Chapter

By the end of this chapter you will have made an accurate master tracing and used it to transfer the various blocks needed for your print onto your plywood along with the guide lines for cutting your kentos.

- You will have an accurate master tracing with your design drawing in its centre, with the margin area surrounding it. When placed over the design drawing, the edges of the master tracing will line up with the frame of the margin area.

- You will have reversed your master tracing by flipping it over.
- You will have two sets of kento guide marks on the edges of your master tracing, one set at the right-hand corner and the other set three-quarters of the way along the bottom edge of the tracing.
- Your plywood will be sanded and stained if required.
- Your blocks will be marked out onto your plywood using carbon paper. Your kento guide lines will be marked out in pencil.
- All your blocks will have a corresponding pair of kento guide lines.

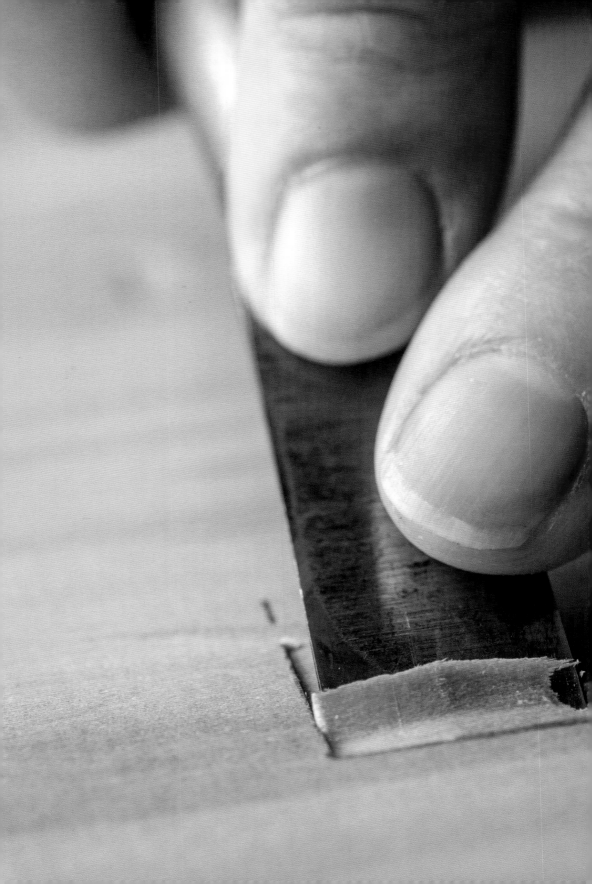

CUTTING THE KENTO TO CREATE REGISTRATION

In Japanese woodblock printing every block has its own individual registration called a 'kento'. The kentos are cut into the wood along with each block, so blocks are always ready to be printed and no additional set-up is required to align them correctly. In this chapter you will learn how to cut kento registration and how to make corrections. Also, Chapter 9 offers an alternative kento solution when your piece of wood is too small to accommodate both block and kento.

The kento system relies on each woodblock having a pair of kento slots cut into the wood. One slot is an L shape and traditionally marks the bottom right-hand corner of the block, the other is a straight slot and sits roughly three-quarters of the way along the bottom of the block. The job of the corner kento is to position the printing paper in the right place both horizontally and vertically. The job of the straight kento slot is to support the printing paper at the right height. There is no need for additional kento slots. When I am printing Japanese woodblocks a metre (40in) or more across I use two kento slots exactly the same size as I would for a print 20cm (8in) across; they are just much wider apart.

OPPOSITE PAGE: **Using the kento chisel to cut a corner kento.**

RIGHT: **Here are two blocks which share the same set of kentos. One block is cut and ready to print, the other is yet to be cut. Both the kentos have been cut and are ready to be used.**

When to Cut Your Kento

There is an argument for not cutting your kento slots properly until after you have printed your first proofs or test prints. Sticking tape along the kento guide lines creates a very temporary guide to position the printing paper while you make your tests. Delaying the cutting of your kentos until after your tests makes it possible to check that you have them drawn in the correct place before you cut them.

The disadvantage for the beginner is that a temporary kento is harder to use than a properly cut kento. It requires skill and practice to position the paper with the accuracy needed to confirm that all is well. It is easy to position the printing paper inaccurately when using a temporary kento and thus make corrections in error, when in reality the kento was drawn in the correct place originally.

I suggest cutting your kentos before you print until you are confident you can place your printing paper precisely where you want. While this won't ensure that all kento slots will work perfectly every time, it will give you a much better chance of discovering if there really is a problem with your registration and, if so, locating exactly where that problem lies.

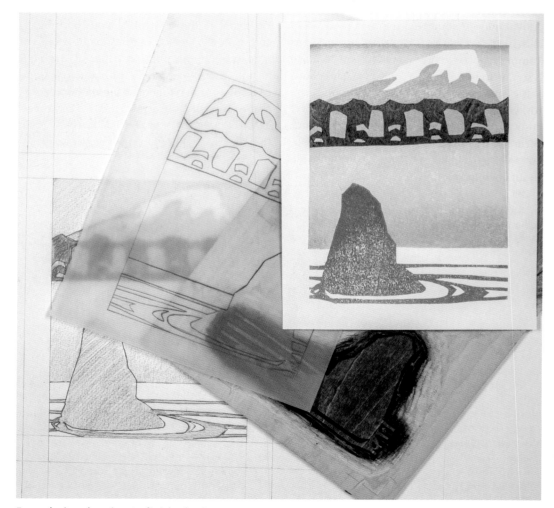

From design drawing to finished print.

Cutting Your Kento

When you come to print, you will be using the kento slots as little shelves to hold your paper in place while you take an impression. Your printing paper will be cut to the same size as your master tracing. Your finished print will have the image in its centre surrounded by a blank margin, the same as your design drawing and your master tracing.

To cut your kento slots, you will need a chisel, a cutting tool with a U profile, plus a non-slip mat or bench hook for safety. As mentioned in Chapter 1, you can use a traditional kento chisel (*kento-nomi*) designed for this task or a woodworking chisel with a short handle, with a blade about 16mm (¾in) wide. Always make sure your wood is secure and won't slip while you are cutting.

It is important that the cut edges of the kentos, where you prop your paper, are clean and crisp and that the right angle of the corner is accurate. Cut some practice kentos before you cut any kentos that matter. Kentos are not hard to cut once you have a feel for how to control the chisel and how deep to go. However, it is best to know what you are doing before your prints depend on it.

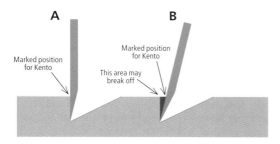

Example A shows a correct cut creating an accurate kento once the second cut, shown here in green, is made. Example B shows how a sloping first cut undercuts the kento and can cause an inaccurate or damaged kento once the second cut is made.

Making the First Chisel Cuts

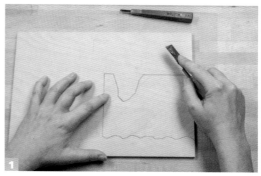

Begin by checking your wood is facing in the right direction for you to make the cuts. Position the wood in front of you with the block you will be printing between you and the kentos you want to cut. This will ensure you cut your kento slots the right way round every time. Hold the chisel with its handle in the palm of your hand and your index finger running down the blade. The flat side of the chisel should face away from you (this is the side your finger will be running down) and the bevelled side should face towards you.

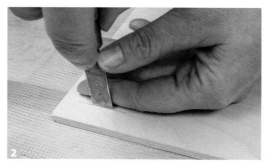

Begin with the straight kento and take your time to position your chisel on your guide line with its blade at ninety degrees to the wood. Use your spare hand to help you position it accurately. Your kento slot should be the width of your chisel and no wider, regardless of the width of your guide lines. Drive your chisel into the wood at an angle of ninety degrees to the wood to a depth of about 2mm. It is essential to make this first cut at ninety degrees. Shina plywood is soft enough to do this by hand, but if you find it difficult, or are working on a harder wood, a light tap with a mallet will do the job.

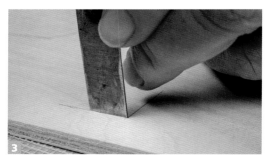

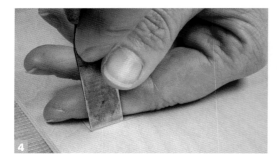

Reposition your chisel in the same way on one side of your corner kento. This time, position it so that one end of the chisel rests exactly at the corner point of the kento. Make the cut in the same way as your first one.

Turn the wood around so that you can position your chisel to complete the right angle and make the second cut.

Making Shoulder Cuts

Putting short cuts, or shoulder cuts, at the outside edges of the initial kento cut serves three purposes: they make it easier to make the second cut that removes the wood to create the little shelf of the kento, they make it easier to position your paper in the kento when you come to print and they make it easier to see the kento while you are printing. To make the shoulder cuts, you will need a U-shaped gouge.

1. Beginning with the straight kento, make a cut at either end of your chisel cut (not your pencil guide line). These cuts should flare outwards away from the block hitting the very edges of the chisel cut. Do not cut across the chisel cuts or your kento slots will be small and fiddly to use.

2. Move onto your corner kento and make two more cuts at either end of the right angle. Do not cut through the corner of your right angle where the two chisel cuts meet. These cuts should also flare outwards.

Making the Second Chisel Cut in the Straight Kento

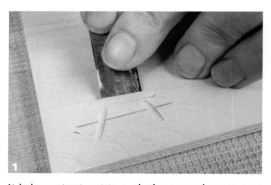

It is important not to rush the second cut as you will be directing your chisel towards your first cut. You want it to stop neatly against the cut, not rammed through it. Hold your chisel in the same way as you held it to make your first cuts, but this time at about forty-five degrees to the wood, about 1cm (½in) away from the kento on the inside of the first cut as it faces you. Using your other hand as a brake, begin sliding the chisel into the wood. You are looking to cut a slot about 2mm deep by the time the chisel makes contact with your first cut.

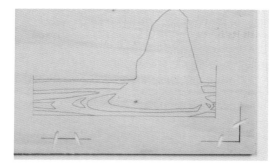

Shoulder cuts help both in the cutting of the kento and at the printing stage.

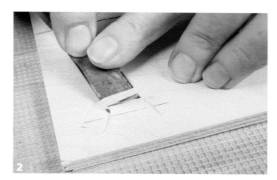

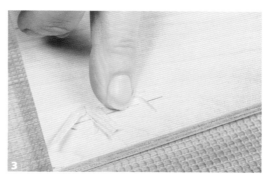

As you move the chisel through the wood, relax and let the elbow of the arm that's doing the cutting swing out and back from your waist. This will move the chisel horizontally from side to side, easing it though the wood for a controlled cut. Stop when you feel the chisel hit your first cut. As long as the first cut is deep enough and you cut with care, you will feel when to stop.

Every instinct you possess will urge you to use the chisel to flip the cut wood out of the newly cut kento slot. Don't do it! It is so easy to damage the crisply cut kento this way. Use your fingertip to remove the cut wood and any stray splinters. If the wood doesn't come away easily, line up your chisel and repeat the first cut, making it deeper.

Making the Second Chisel Cut in the Corner Kento

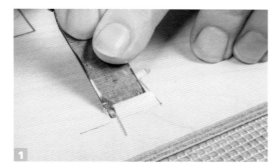

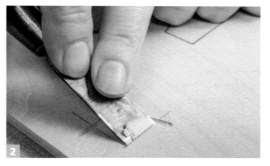

Begin by positioning your chisel, exactly as you did for the straight kento above, but this time along one side of your corner kento. Keep it about 2mm away from the chisel cut that makes up the remainder of the corner. You don't want to damage the other half of your corner kento while you are making this cut. Make your cut in exactly the same way as you did with the straight kento and remove the cut wood.

Turn the wood to make it easy to make the second cut. Make the cut, but watch that the edge of the chisel isn't going to damage the other half of your kento while you complete your cutting. Remove the cut wood and check the kento for any splinters.

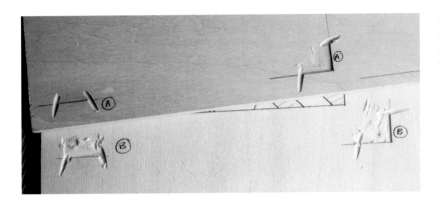

Both these sets of kentos will work when printing, but the A kentos will be easier to use.

Repairing Kentos

To begin with you may damage a kento while you are cutting it. While it is not ideal, the slope of the kento towards the first chisel cut can be untidy, as can the flared shoulder cuts, and the kento will still work. However, the edge of the kento, as defined by the first chisel cut into the wood, must be crisp, clean and accurate for ease of printing and a good result.

- If the edge of your straight kento is lifting away or chipped, you can cut another beside it, either using your existing pencil guide line or using your master tracing to map out another. Provided your second straight kento is far enough away from your corner kento to hold your printing paper level, it will

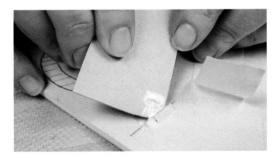

Masking tape holds the wood back into place while the glue is drying. At a pinch the masking tape can also act as a false edge for a kento where the wood is too splintered to glue back into place.

work perfectly. If this is not possible, you will need to repair the kento in the same way as described for a corner kento.

- If you need to repair a corner kento that is chipped or lifting, the best way is to slide some waterproof wood glue under the edge of the wood where it is lifting and then tape the wood down while it dries. Once the glue is dry, the kento will be as strong as a new kento.
- If the wood has splintered too much for you to stick it back into place, you can use a strong masking tape to stick along the edge of your kento to create a guide against which to rest the printing paper. You will need to make sure that the edge of the tape lies exactly along the first chisel cut for the kento to be accurate. This is not ideal; you will need to be very careful with it when you are printing, but it works in an emergency.

Repositioning Your Kento

To assess if you have a registration problem, you will need to make a complete proof print first, so come back to this section after Chapter 6.

First establish if the problem is one of registration or of cutting the blocks. If the problem lies with your cutting of the blocks, the misalignment will be a random error affecting part of the block you are printing, with other areas lining up correctly. If

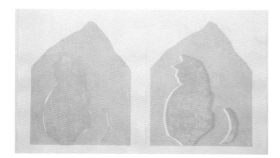

the problem lies with the registration, the misalignment will be consistent and the whole block will look like it is hitched too far in a single direction.

When you are sure the error is one of registration, it is worth printing a further proof to check that you have positioned your paper correctly when printing. Some kento issues vanish with the next printing! Once you are sure that there is an error, check how all your blocks are fitting together in the finished print to locate the problem block.

Allow your block to dry thoroughly and then line up the master tracing accurately on top of the block. Once it is in place, look to see where the kento should lie and mark the place as needed. Take a test print using the new position to assess if it is correct and make any adjustments before making any permanent corrections.

Goals for This Chapter

By the end of this chapter, you will have cut your kento.

* You will have practised cutting corner and straight kento slots.
* You will have cut the kento for your printing blocks.
* You will have repaired the kentos if they were damaged in the cutting.
* You will know how to move your kentos if your blocks are out of alignment when you come to print.

LEFT: **On the left, the error is with the cutting of the block and shows as an error only in parts of the print. On the right, the whole cat block appears moved to one side. This is a registration error.**

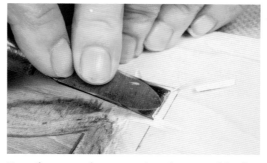

Here the corner kento needs to be moved further away from the block. The new position can be cut into fresh wood to make a new kento.

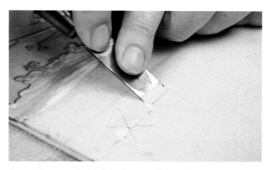

Here the straight kento needs to be closer to the block so a second kento is marked and cut beside the first.

Here the corner kento needs to be moved inside the block. The new position is marked and layers of masking tape added, creating a new corner kento.

CUTTING THE WOODBLOCK

The Block

At this stage you will have your blocks mapped out onto your plywood, probably more than one block per side of wood. To prepare the blocks for printing, you will cut their outline with the *hangi-to* knife described below and then use the other tools to cut a trench around each block for clearance. Each block resembles an island with a moat surrounding it when cut. Remember that you can always shade in the block to remind you where not to cut.

OPPOSITE PAGE: **Cutting tools lie among wood shavings while the carver works.**

The Hangi-to Knife

Along with the tools detailed below, the hangi-to knife cuts the woodblock ready for printing. It is unique to Japanese woodblock printing and it makes the first cut, outlining the block. In traditional printing, it is the knife used by the master carver to cut a key or line block (*see* Introduction). If you are left-handed, you will need to buy a left-handed hangi-to; this is the only tool where this is necessary.

The hangi-to is held in the fist, with the longest part of the blade near your fingers and the shortest part near your wrist. It cuts on the pull and must fit the hand. Hangi-to knives usually come with longer handles than needed,

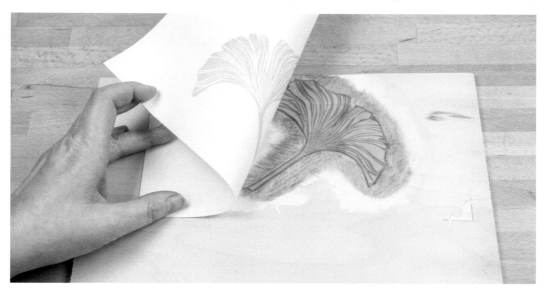

The printing block is isolated by a trench cut in the wood. During printing a well-cut trench will hold surplus paint low enough for it not to transfer to the paper during printing, giving a clean result.

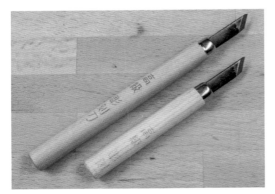

These hangi-to came as part of a set. One has been cut down to the correct length.

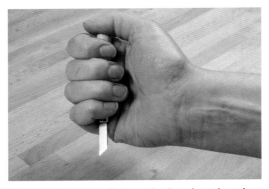

The hangi-to must fit into the hand so that the thumb can rest easily on the top of the knife handle and the length of the metal blade is exposed below the hand. Trim to length with care to ensure good control and comfort while using your knife.

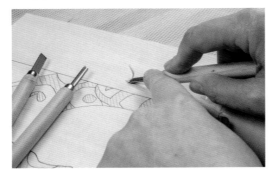

All the U gouges and chisels are held in the same way and cut on the push, away from the user. Your spare hand can be used to stabilize the blade and steady the wood while cutting if you wish.

especially those provided as part of a set. You will probably need to trim down the handle to fit into your fist so avoid hangi-to knives with plastic handles. It is essential that your hangi-to fits into your fist with your thumb resting on the top of the handle. If the knife is left with a long handle, it is much harder to control. The hangi-to is the only tool that requires trimming to size.

Maru-nomi (U Gouges) and *Aisuki* (Chisels)

In addition to the hangi-to, you will need tools for clearing out the wood around your block. Traditionally the tools used were flat chisels and U gouges; now V-shaped tools are included in most sets of tools and are a useful addition. There are good sets available that are economical and include all the essential tools, including a hangi-to. If you wish to buy tools singly then a small selection of U, V and chisel tools in different widths will give you an excellent starting point.

U gouges and chisels are held with the handle in the palm and the forefinger running down towards the blade in exactly the same way as you hold the kento chisel. They cut on the push, away from your body.

The Sankakuto (V Tool)

The V tool is a modern addition to Japanese woodblock and is held in the same way as the chisels and gouges, also cutting on the push. While the hangi-to is the correct tool for cutting the outline of your block, the V tool can make an outline cut instead, giving a sloping profile into the wood. That said, it is not as precise or useful for outline cutting as the hangi-to and I really can't recommend it for this purpose.

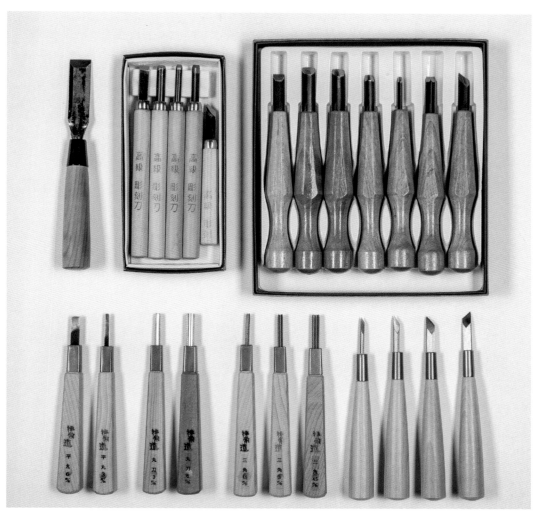

It can be helpful and economical to start with a set of basic tools and build on your collection as your skills increase.

A V tool comes into its own for creative mark making and 'drawing' into the surface of your block. It is possible to cut very fluid lines with a V tool; I often use them for spontaneous mark making.

RIGHT: **This block has been cut with a V tool to give a fluid surface pattern. Taking a rubbing using newsprint and a graphite stick is a helpful way to check your cutting.**

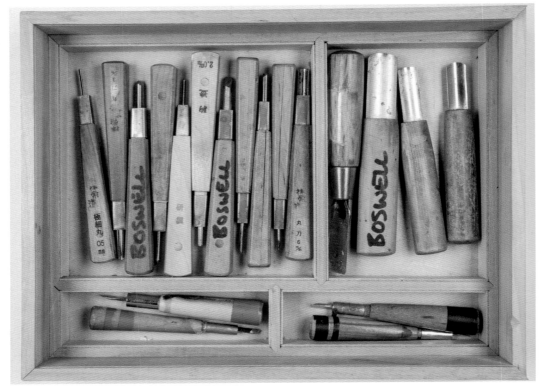

My tools are stored in this leather-lined box, made for me by my husband.

Care of Your Tools

It is sensible to keep your tools in a tool roll, or a box lined with a soft material, to protect the blades. Individual tool blades can be protected by rubber tubing or by inserting into a clean dry cork. Clean and rub the tools lightly with camellia oil regularly to keep them free of rust. For advice on sharpening tools, *see* Chapter 9.

Making the Outline Cut with the Hangi-to

The hangi-to knife makes the first cut. Its job is to make a sloping cut around the woodblock so that the block will give a clean crisp print. To begin with, using the hangi-to may feel very strange and somewhat awkward, but do persist. Once you become used to using it, you will find

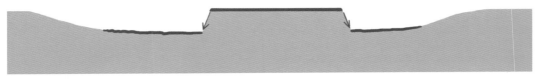

This diagram shows a block and blue paint ready for printing. Its profile is wider at the base and narrower at the top due to the sloping cut made by the hangi-to knife.

Cutting in the right direction with your hangi-to is crucial to producing a stable woodblock. Remember the rule that the area that is going to be printed must lie under the hand doing the cutting and you will always cut in the right direction. If you are still in doubt, exaggerate the tilt of your hand and look at the tip of your blade. If it points away from the block's outline into the rest of the wood, you are cutting correctly. If the tip points into the block, the blade will undercut the block and weaken it.

its precision and efficiency essential for cutting a crisp outline.

Creating a sloping cut with the hangi-to is very important. By cutting the block with the base wider than the top, the knife creates a sturdy pro-file and the block is less likely to chip or break. The sloping sides allow the unwanted paint to travel cleanly down the sides of the block to lie in the cut-away trench. This prevents paint pooling against

It is a good idea to use your other hand on the back of the blade shank for stability. It will also hold the wood steady and keep your fingers safely behind the blade. Practise until you feel comfortable.

Using the tip of the knife, begin at an uncomplicated part of your block and insert the tip about 1–2mm into the wood. If you are using shina ply, as I suggest, aim to cut down to the layer of ply just underneath the top layer. You'll find out if the depth is correct once you start clearing out the wood around your first cut. You'll quickly get a feel for the cutting depth after cutting a couple of blocks.

RIGHT: Make a sloping cut along the line. Aim for the outside edge of your line if you can and run the blade along in a straight line towards you. Don't try to make the hangi-to go around corners. Instead, allow your cut to come off the line away from the block. If coming off the line would mean cutting into your block, stop carefully and bring the tip out of the wood at the end of the line and before it cuts into the block. Move the wood and then rejoin the line again once the wood is in the right place. You will end up with a series of cuts coming off the line and rejoining it where the wood has needed moving.

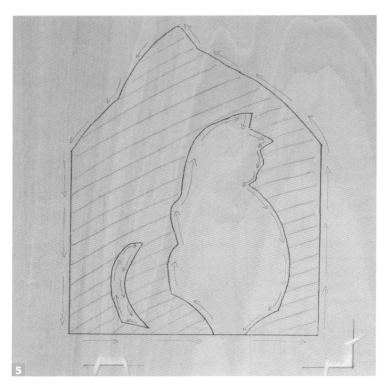

Remember that if you have areas to cut away inside your block, you will still need to make sure your knife is sloping into the wood that is being removed and not into the block itself. To do this you will reverse the direction of your cutting. Here, arrows mark the direction of an outside cut and an inside cut for a right-handed person.

Once you have cut the outline of the block, you need to protect that cut by clearing away a sliver of wood around the block before you use your other tools for clearing out a wider trench. To do this, run a series of counter-cuts around the block with the hangi-to, no more than a couple of millimetres away from your initial cut, but in the *opposite direction*. A splinter of wood will fall away to expose the sloping edge of your block.

This diagram shows the original sloping cut in red and the counter-cut in blue; the sliver of wood falls away to expose the block.

the edge of the block and so avoids the risk of blurry edges to the print. It is important that you cut the block so that the cut slopes wider at the base than at the top. If you cut your slope in the other direction so the top is wider than the base, the woodblock is very likely to chip and come apart during printing. Follow the steps 1 to 5 carefully.

Hold the hangi-to in your hand and relax, so that your hand is at a slight angle away from your body. That is the slope that you will transfer to the block as you cut. You will only use the tip of the hangi-to to cut with, not the full blade, and you will pull the tip of the knife through the wood to make the cut.

Cutting the Trench around Your Block

The purpose of cutting away a layer of wood to make a trench around each block is to provide a wide enough area of lower wood to accommodate the excess paint from the printing bush deposited while you ink the block. Your trench needs to completely encircle the block except where the block is on the edge of your wood. If you are used to inking up with a roller, remember that inking with a brush means you don't have to clear away all the unwanted surface area; 3cm (1¼in) wide around each block will do for normal printing conditions. In the early days, it is better to err by making your trench too wide rather than too narrow.

Time spent cutting a wide clean trench now will be time saved when you come to print. Skimping by cutting a narrow trench will hold up your printing while you fiddle your brush around your block, keeping it from inking in the wrong place. It is easy to think that you can just use a smaller printing brush and solve the issue that way, but the smaller the brush, the more you will have to wash and dry it during printing and that's no fun either!

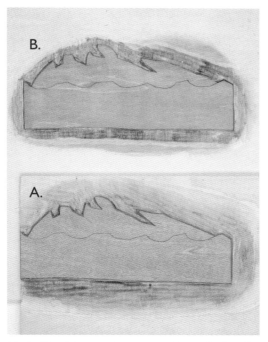

Block A's wide trench accommodates the brush easily for clean printing. Block B has a narrow trench and is much harder to ink, resulting in overspill onto the wood surface, giving a messy result.

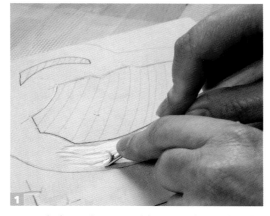

It may help to draw a guide around your block about 3cm (1¼in) wide. Using a U gouge, begin clearing away the wood until you either hit the next layer of ply (you'll see the wood change colour at the second layer) or go a little deeper; 2mm is deep enough. It is fine to clear wood away right up to the inside of the kento as long as you don't remove the kento's cut edge.

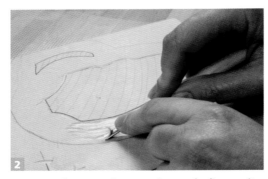

Once you have made a rough trench, finesse it by smoothing off the ridges left by the U gouge using a chisel or wide U gouge.

Check your cleared trench for any high spots or unwanted ridges. Touch is better than sight for this. No need to go beyond the second layer of ply or about 2mm deep.

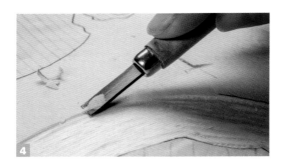

Using a chisel, smooth off the hard edges at the outside of your trench so that they will not emboss on the paper when you come to print, leaving a finished block ready for printing.
If the chisel catches in the wood while you smooth, turn the wood and try cutting from a different direction.

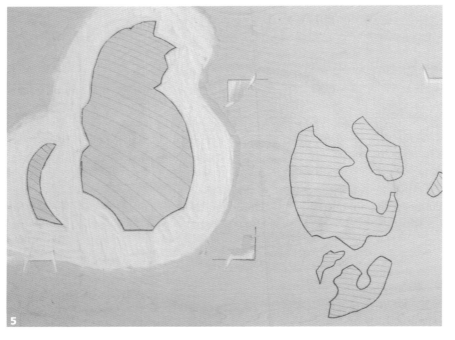

When finished, your block should look like this.

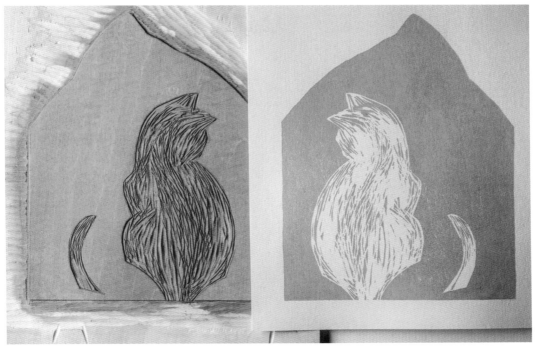

Here the ridges left in the block provide 'chatter' that adds depth and texture. In this example, the cat area was cleaned out using a V tool while the outside trench was cleared to print without chatter. U gouges would leave softer 'scooping' chatter marks.

Cutting a Clean Trench

Your initial outline cut should be one or two millimetres deep and your trench will need to be at least this deep and about 3cm (1¼in) wide around the block. If you have other blocks on the same kento that are closer than 3cm (1¼in), just clear out a trench between them. Don't go too deep with your trench when cutting, especially when you are using both sides of the block. It's not necessary to cut beyond 2mm deep.

Chatter

By 'chatter' I mean rogue ridges or high areas of wood in the trench around your block that will catch ink and print. Chatter can add character and interest to a print if it is used well. If you plan to use chatter, remember to clear your trench sympathetically so that the chatter works in harmony with the block. For instance, if you want curvy chatter lines to add interest to an undulating landscape, do not cut the trench with hard straight lines. Remember that chatter never looks good overlapping into the clean margins of your print, so be sure that any margin areas are cut away to print clean with no chatter.

Troubleshooting the Blockcutting Process

Mistakes made while cutting your blocks need assessing. Repairs can be made, but occasionally it is better to write off the loss and cut a new block.

Undercutting the Block with the Hangi-to or Parts of the Block Lifting Away from the Wood

- If the block is still in one piece, a direction error with the hangi-to may not affect the printing. Be aware of the undercut edge when you come to print, being sure to use your brush to clear any paint pooling under the block's edge.
- If the edge of the block starts to lift up, slide some waterproof wood glue under the edge and press down to dry. Print with care as before if the block is undercut.
- If part of the block comes adrift completely, but you still have the wood in question, you may be able to stick it in place with waterproof wood glue. Use fine sandpaper very gently to hide any join. Do be aware it may show or fail.

Inadvertently Slicing into the Block with the Hangi-to

- If you have a fine cut in your block, you can rub a little sawdust mixed with waterproof wood glue into the cut. Let it dry and then rub over gently with fine sandpaper.
- Don't attempt to use the glue and sawdust mix for any damage larger than a fine line. It is not as absorbent as the wood and is likely to show as a dark area on your finished print.

Missing the Outline and Cutting a Different Profile around the Block

- Weigh up how this will affect your block: if it is absolutely crucial that the block lines up exactly with another you will need to cut a replacement block.
- If the block is an overlay or doesn't need to line up with another block, accept the new profile and use the block in your print. Only when you have a proof print is it worth deciding if you are happy, or if you need to cut a more accurate replacement block.

Cutting a Chunk off a Block by Mistake

If you still have the piece, stick it back to the block using waterproof wood glue and, as always, wait for it to dry properly before printing. If you have lost the piece, you need to make and insert a wooden patch and recut the area. This is a tricky job and it is probably better to just cut a new block. If you want to attempt it, here is how to try a repair.

- Use a small chisel to cut yourself a replacement piece of wood from your plywood. Repairs like this are slightly easier using ply as you can remove a piece of the top layer of the ply with the chisel to replace the missing piece.
- Clean away the area around the mistake and insert your wood patch and glue.
- When it is dry, redraw your guide lines using the master tracing and recut.
- Sand gently to hide the joins. You may need to create some sawdust by sanding some spare wood and mix it with the wood glue to fill in the gaps in your joins.

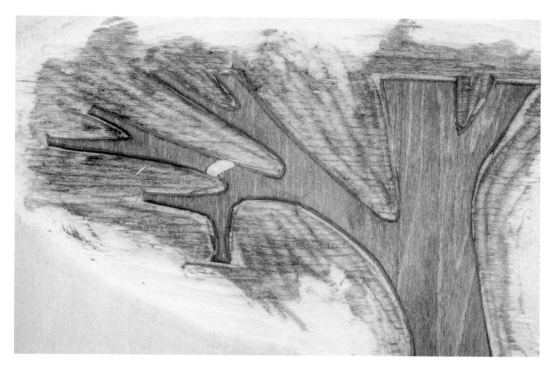

This repair takes practice, but can save the day if cutting a new block is not an option or the damaged block is very precious.

Goals for This Chapter

By the end of this chapter you will have learned how to use a traditional hangi-to to cut the outline of the blocks and how to clear a trench around each block, preparing each block in turn for printing.

- Your blocks will have a sloping profile with their bases wider than their tops.
- You will have counter-cut your outline cut to remove a splinter from around your blocks ready for the trench to be cleared.
- You will have cut a clearance trench around each block, deciding to cut clean or use chatter as preferred.
- You will have smoothed the outside edge of your trench to avoid embossing marks on your finished print.

PAPER PREPARATION

Japanese woodblock prints can consist of many more layers of colour than their Western counterparts. This is because the individual printing blocks are often inked several times to bring vibrancy and dimension to the print using shading effects in addition to flat colour. Japanese woodblocks are printed onto damp paper with no drying between layers and this, along with the multiple layers of printing, demands a durable paper with good wet strength. In this chapter you will learn about papers and how to prepare them for printing.

Japanese Paper

Japanese woodblock prints are traditionally printed onto Japanese *washi* paper. Washi paper is uniquely suited to the Japanese method of woodblock printing because of the way the paper is constructed. Traditionally washi is made from the fibres of *kozo* (paper mulberry), *gampi* or *mitsumata* plants. These days other materials, such as cotton or bamboo, are sometimes added.

In very simple terms, the white inner bark of the branches from these plants is separated from the outer bark and passes through several stages of cleaning and beating to produce long regular fibres ready for papermaking. The long

OPPOSITE PAGE: Brushing water onto sheets of newspaper to make a damp pack.

fibres are then suspended in water mixed with a mucilaginous liquid called *neri*, traditionally extracted from *tororoaoi* (hibiscus root), ready to make the paper.

When making washi paper by hand, the papermaker uses a wooden frame called a deckle, which is lined with finely slatted bamboo, to scoop up the fibres and water. The papermaker then rocks and shakes the deckle to lock the long plant fibres together and to even out the layer of paper, the number of dippings controlling the thickness of the paper. Machine-made washi mimics this process. The resulting paper is exceptionally strong and durable with excellent wet strength. The long fibre content allows for even expansion and contraction when wetting and drying. These are all features desirable in paper for Japanese woodblock printing.

Washi paper for printing is increasingly available in the West. It can be a confusing paper to buy, with many different sizes, names and characteristics. Handmade papers are always the most expensive, but are very beautiful and rewarding to print on. Machine-made washi papers offer a very satisfactory and more affordable alternative. Most of the suppliers listed in this book will offer a sample set of Japanese washi papers to try as a starting point. While I have suggested a good economy Western paper for your early projects, I urge you to try to move on to using washi. It is the authentic and most sympathetic paper for this process and will enrich the colours in your prints while adding a beautiful luminosity.

A selection of different washi papers for Japanese woodblock printing.

Economical Paper for Early Prints

It is best to use a cheap and readily available paper for your early prints. Lots of practice is the trick to mastering this printmaking process and, by using an economical paper, you will be more comfortable about the inevitable wastage while you learn your craft. I teach with Fabriano Academia HP 200gsm and find it an excellent and affordable paper for beginners. With washi the undisputed king of printing papers for Japanese woodblock, it may seem odd to recommend starting with a Western paper, so here are a few pros and cons.

- It is easier for the novice to handle a sturdier paper when learning to print a Japanese woodblock. Heavier weights of paper (150gsm or more) are easier to position on the block and are less likely to slump into your cut-away areas, making it easier to get a clean result. While Western papers (like the Fabriano Academia HP 200gsm I use) are readily available and affordable, the same is not so much the case with heavy washi. Most washi in the UK is of lighter weight and not so easily handled, the heavier-weight papers tending to be more costly and less common.

- Washi is a startlingly honest paper for a beginner. It will show every imperfection, brush mark and spot of paint. While this is part of its beauty, a clean result does rely on experience in cutting, inking up and taking an impression. Western paper is less sensitive and will give satisfactory results more quickly, which is important for encouraging the beginner. Revel in the beautiful sensitivity of washi when you have a little more confidence and experience.

- Because washi takes the paint right into the fibres of the paper, colours are richer and

deeper than they appear on Western papers and washi seldom requires any blotting. Western papers may need a more intense mix of pigment and possibly double printing to achieve the similar rich results. You are also likely to need to blot excess paint from Western paper when learning, but this tends to lessen with experience.

- Large paper size is unlikely to be an issue with early prints, but if you do go on to make large prints washi may not be available in large sizes except as a special order. I have worked on prints over a metre (40in) wide using Fabriano Academia successfully.

Sizing Paper for Printing

Size, or *dosa* as it is known in Japan, is a combination of animal glue and alum (aluminium potassium sulphate) used to coat printing paper to improve its performance and strength. While many Japanese washi papers are sold unsized and need treating, the Western paper mentioned here does not require sizing.

When using any new paper I find the best way to check if it needs size is to take a test print. If the paint sinks into the paper and bleeds, like ink on blotting paper, or the surface of the paper has loose fibres, or seems likely to rub and wear as you print, you need to size the paper.

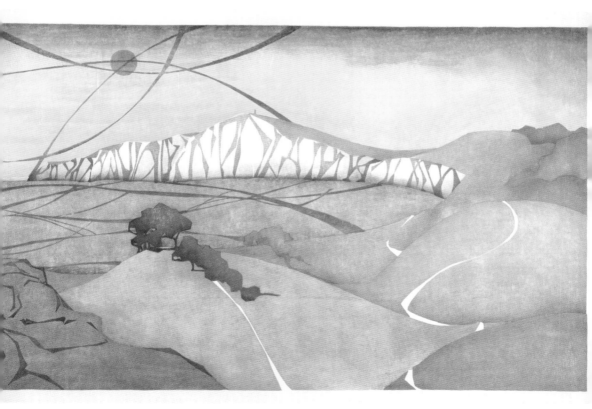

Tennyson Down. This print of the Isle of Wight is over a metre wide and printed on Fabriano Academia HP 200gsm.

Dosa Recipe

Many dosa recipes exist; this is a basic guide and the one I use. Please note that animal glues vary in strength, as does vegetable gelatine, so it is important that you test this recipe using your preferred ingredients and papers before sizing anything important. Be prepared to experiment further with other recipes if this one does not satisfy your needs.

- 20g of rabbitskin glue or *nikawa* (the Japanese version); if you prefer not to use animal products, vegetable gelatine can be substituted
- 10g of alum (aluminium potassium sulphate is preferable to aluminium sulphate)
- 500ml water.

Method
- Warm the glue in a little water to soften it, stirring constantly. Do not boil.
- Bring the remaining water to the boil and allow it to cool slightly. Add it to the water and glue mixture, stirring until the glue is dissolved.
- Add the alum and strain the mixture through muslin and cool to room temperature before using.
- The mixture will keep in the fridge for a week or two, but I recommend sizing your paper in batches with fresh size rather than keeping it.

You will need a large flat surface, a towel and a wide brush for sizing. A traditional *dosa bake* (sizing brush) made with white goat hair is excellent, but a simple decorator's brush will do the job. You may like to practise with water and newspaper to achieve the neat and even application needed.

It is important that the dosa is clean and free of impurities.

Cover a flat surface with a towel larger than the paper you want to size and lay your paper down right side upwards (the smooth side of the paper is normally considered the right side to print on).

Dip your brush in the dosa and brush off the excess on the side of the bowl. The aim is to transfer as thin and consistent a layer of dosa to the paper as possible, so do not overload the brush.

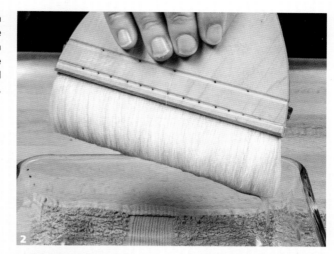

Draw the brush evenly across the paper in a single stroke.

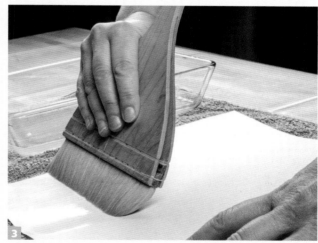

Work across the paper, adding the new stroke against the one before, without overlapping, until the paper is coated. Looking with eyes level with the paper will help you to see any dry or missed areas. These can be touched in carefully with the edge of the brush. Leave the paper to dry thoroughly or the dosa will glue the damp paper sheets to each other. The reverse of the paper can be sized in the same way if you wish to add additional strength to the paper to protect it during printing. Paper can be sized in bulk and stored for six months to a year.

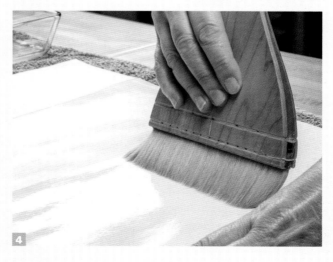

Proofing Paper

Even more economical paper can be used for making proof or 'tester' prints. A decorator's lining paper, for wallpapering walls that are to be painted, works very well. A roll of mid-priced lining paper from a DIY store will provide many test prints very cheaply and is comparable to 200gsm weight papers. This paper will not give you the bright colours of a finished print, but it is good-natured, sturdy and will allow you to check your print for cutting corrections and give you a general idea of colours and where to place shadings, etc. It is also useful for checking that your block is the correct dampness and printing at its best before you move on to better paper.

The low angle of the kiridashi cuts the long-fibred washi paper without tearing.

edge to your paper for accurate positioning in the kento, any rough or deckled edges will need to be removed.

Newsprint

It is useful to have blank newsprint available for taking rubbings while cutting, for blotting if you are printing with a Western paper and also for making 'trash prints' when working colour and rice into a new block. It can be bought cheaply in bulk by weight as packing material from packaging companies.

Cutting Paper for Printing

Your paper for printing needs to be the same size as your master tracing (the size of your design drawing and its margin area). Accurate corners are essential for registration so take care when cutting. When cutting washi with a craft knife or box cutter, it is easy to tear the long fibres of the paper and spoil the cut. A sloping knife called a *kiridashi* is an inexpensive tool, available from online suppliers. This can be held at a much lower angle to the paper when cutting, allowing you to cut washi cleanly. As you will need a clean

Damping Paper for Printing

Japanese woodblock requires paper to be damp throughout the printing process. You will be moving your paper from wet printing block to wet printing block, so the paper must be damp for it to lie flat on every block and retain accurate registration. If dry paper were used, it would cockle after the first block was printed, making it impossible to lay the paper down accurately on the other blocks. Equally important, the paper must remain at the same level of dampness throughout printing or it may change size, affecting the registration.

Paper can be damped ahead of use. You can damp your printing paper on the day before you intend to print to save time. However, once paper is damp, mould is a threat, so only damp paper for use the next day. Once you begin to print, the addition of rice starch to the damp paper increases the risk of mould, so prints should be completed within one or two days. Australian printers recommend a scant drop of

essential tea tree oil in the damping water to discourage mould and this works extremely well in my experience, with the studio nicely scented as a bonus!

If you cannot complete your print within a couple of days, it is possible to freeze your prints and thaw them out when needed. Alternatively, you can remove them from the damp pack and allow to air-dry. When you are ready to resume printing, prepare two damp packs. Insert the prints into one pack interleaved between the damp pages and leave until damp. When damp, remove them from the first damp pack, which will now be too dry to use, and insert into the second damp pack.

Tacking blotting paper into an old sheet will prevent tearing and pilling when handling. A strip of cotton fabric is a compromise that helps prevent tearing only.

Using a Damp Pack

The easiest way to keep printing paper consistently damp is to use a damp pack. This is a plastic folder with a sandwich of damp blotting paper or newspaper inside. The printing paper remains stacked inside the damp pack throughout the printing process. It only leaves the damp pack briefly when colour is applied. With good management the paint from the print will not transfer to the damp pack or to the other prints. See Chapter 6.

If your print is small enough, a printed newspaper makes a good pack. Provided you allow a couple of weeks for the newspaper ink to settle before using it in your pack and don't apply direct weight to the pack, the newsprint will not transfer to your work. This means no leaning on the damp pack or using it as a surface for blotting!

Blotting paper is a more expensive option, but is extremely stable when damp. It also comes in large sizes for bigger work. It can be reused but is prone to tearing and pilling over time. To prolong the life of blotting paper, you can tack each sheet into thin fabric like old cotton sheeting before damping. If you take the time to do this, allow a little space in the sheeting for the blotting paper to expand and ensure the paper and sheet are completely dry before storing for next time. If this seems too much work, strips of dampened cotton can be folded around the exposed edges of the blotting paper to prevent tearing when the paper is lifted.

Preparing a Newspaper Damp Pack

You will need:
- A sheet of sturdy polythene or plastic. This sheet should be large enough to allow for tucking the edges under the damp pack to keep work damp during any break in printing. Economy plastic shower curtains are a good option.
- A large brush. Your brush could be a proper Japanese water brush (*mizu bake*) or a large decorator's brush.
- A bucket or tray of water. Clean cat litter trays are perfect for this.
- Enough newspaper to have a pack of about eight sheets with the newspaper opened out flat (sixteen pages when the paper is folded normally). This will make a damp pack fat enough to remain stable and damp even if one or two of the outside layers begin to dry.

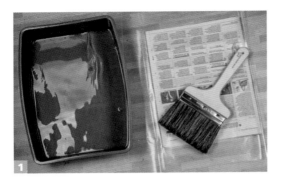

Lay the newspaper, folded normally, in your plastic folder.

The aim here is for the newspaper to be damp to the touch, the pages smooth and for each page to open separately. If your pack is so wet that the pages won't separate, slide in a few pages of dry newspaper to soak up excess water. If the paper is patchily too dry, brush on more water through the pack and leave to distribute as before.

Preparing a Blotting Paper Damp Pack

For a blotting paper pack, you will need to follow the same steps as for newspaper, but you will only need a pack of two or three sheets folded in half. Damp each sheet of blotting paper thoroughly, whether tacked into fabric or not, and smooth it carefully with your hands before closing the plastic and leaving it under a weight as above. If you are using cotton strips, wait until the blotting paper is ready, soak the strips in water and wring them out. Fold them over the exposed edges of the paper.

Beginning at the back of the newspaper, count off three pages and brush with water as if you were applying paste to wallpaper. You are aiming to damp the newspaper well, not to drench it completely. Count off three more sheets and repeat until you have worked through the whole newspaper.

Level of Damping

How you damp your paper will depend on its weight and type. Washi papers are much quicker to absorb water than Western papers. You want the paper damp enough to lie flat, but not so wet that it is flimsy and hard to handle. You may need to damp each sheet of heavier-weight paper in the 200gsm range individually, while a lighter paper may only need every second or third sheet dampened. Very lightweight washi can simply be inserted into the damp pack and left to absorb moisture. You will need to experiment to achieve easily handled just-damp paper.

Don't be dismayed by the rumpled pack. Close the plastic and put the pack under a light weight, such as a tray or cutting mat, and leave it for an hour or so while it smooths itself out. Once the water has diffused through the pack and the newspaper is evenly damp, you can add the printing paper.

Maintaining Dampness while Working

- As you print, get into the rhythm of taking printing paper out of the pack, printing and immediately replacing your paper into the damp pack as described in the next chapter. If you wish to keep a print out to look at, either put it in a plastic folder or under the plastic wrapped around your damp pack.
- Always remember to keep the plastic sheet closed over your damp pack while working. The tidier the pack remains the better; you may need to stop and realign your damp pack from time to time.
- Keep your prints in the middle area of your damp pack.
- Keep an eye on the damp pack. The outside sheets may start to dry, especially when using newspaper. Take your water brush and gently damp the top and bottom outside sheets of the damp pack, making sure there are no prints inside these layers.

If you have to leave your printing, tuck in the edges of the plastic to keep the damp pack from drying out. If you are leaving the pack overnight at the end of a day's printing, you may like to dampen the front and back of the pack slightly before folding over the plastic and leaving it.

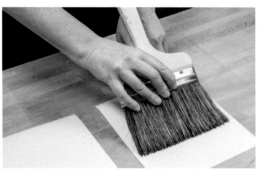

In this example Fabriano Academia HP 200gsm is used. Make a stack of paper to be damped on a clean surface. If your paper has a right side, place that face down. Take the water brush you used to wet the damp pack and wipe off the excess water. Draw it over the paper evenly. (If you are damping washi, damp the rougher back of the paper, not the smooth front.)

Stagger the paper in the damp pack as you work. If you are only wetting every other sheet, add the dry sheets in between the damp papers as you go. Insert your damp stack of printing paper into your damp pack and leave for at least an hour or overnight without a weight on top. A paper marker in the damp pack will help you to find the paper easily while printing.

Goals for This Chapter

By the end of this chapter you will have learned the difference between washi and Western papers, whether or not to size the papers with dosa before printing and how to prepare your chosen paper for printing.

- You will have chosen an appropriate paper for your project.
- You will have cut it to the correct size.
- You will have prepared a damp pack.
- You will have damped your printing paper and placed it in the damp pack ready for printing.

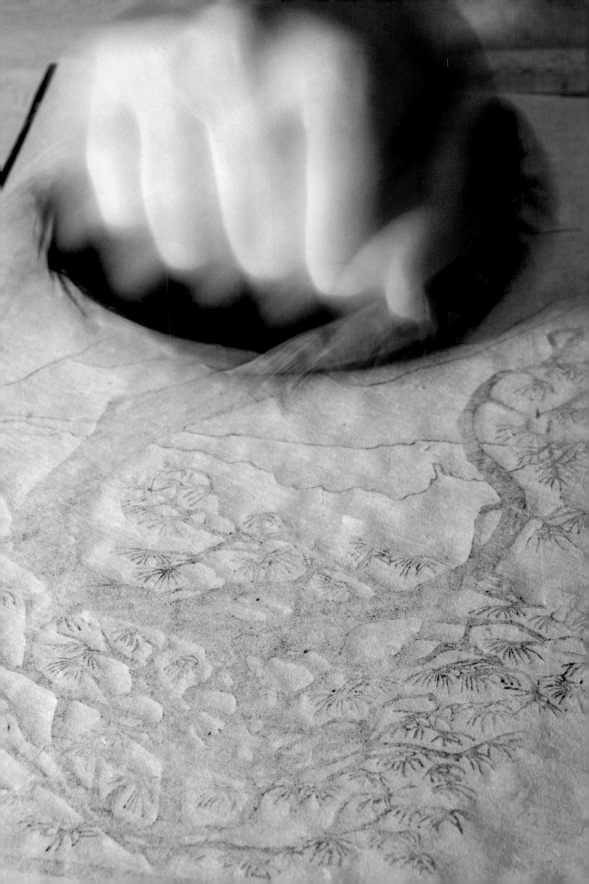

PREPARING FOR PRINTING AND TAKING PRACTICE PRINTS

To take a print from your blocks, you will be using a combination of paint and rice paste (nori) applied to your dampened block using a printing brush. You will print the paper by hand using a circular tool called a *baren*. In this chapter you will learn about these tools along with how to prepare rice paste, how to condition your blocks for printing and how to print a flat sheet of colour.

Paints for Printing

It is important that you use water-based paints for Japanese woodblock printing. Oil or acrylic paints will not print well and may prevent the block working with water-based colour in the future. Although watercolours and gouache are both suitable for this process, I recommend beginning with watercolour as it is the more versatile of the two. Working with tubes of paint is the easiest option, as you will need to mix bowls of liquid paint for printing. As with the paper, it is sensible to practise with an economical brand, saving top-quality paints for editioning or important work.

Black is an exception from standard paint as sumi ink is the preferable choice. Sumi is made from the soot of burnt pine oil and gives a rich colour. Liquid sumi (also used in Chinese brush painting) is readily available and can be used

OPPOSITE PAGE: **Taking an impression using a bamboo baren.**

neat or diluted like the watercolours. It is applied in the same way, also with the addition of nori.

Preparing Paint for Printing

Mixing watercolour or gouache paint for Japanese woodblock printing is very much akin to mixing colours for painting: for stronger colour, use more pigment; for paler colour, dilute with water. The mix does not have to have a fixed consistency; you can print with anything from barely tinted water through to paint straight from the tube. However, you should bear in mind that your paint will be diluted slightly by mixing with nori when taking the print and also, during early printing, the block will absorb some of the colour so be a little bolder with your colours than you think you need. You can always adjust the colours later.

When using watercolour, just as in painting, adding white to a mix will make the paint chalky and slightly opaque. Lightening a colour by dilution will keep the colour delicate and translucent while adding white will give solidity. Think about the subject matter before choosing between diluting your paint or adding white to make a paler colour. It is a good idea to have paper scraps available to test colours. Do this by putting a small drop of paint on the scrap paper and smearing it across the paper with your thumb to get an idea of the printed colour. You may also like to make colour notes as these can come in useful when editioning. *See* Chapter 8.

Watercolour and sumi ink mixed in small bowls ready for printing along with a colour test sheet. A water bottle like this safety wash bottle makes mixing paint and damping the block neat and easy.

Nori (Rice Paste)

Rice paste, or nori, is essential to Japanese woodblock printing. The nori works in several ways: it combines with the paint to create a smooth sheet of colour on the paper, it lubricates the paint enabling it to slide over the block, it gives the paint more body and slows the paint's drying time, and it also helps to hold the paper in place while printing. Without nori the paint will barely print, resulting in a blotchy, uneven layer. Nori is available ready-made in tubes, but it is easily made from white rice flour at home.

Nori is applied to the block directly, separately from the paint. This is because the balance between rice and paint varies according to the block, the brushes, the paper, the weather and the effect you want. Applying paint and nori separately allows you to make the adjustments needed. This sounds intimidating, but you will quickly come to understand the balance involved as you practise. The other reason for keeping nori separate is one of economy: paints mixed with rice will spoil while pure paint can be rehydrated and reused.

The balance of nori to paint is not an exact science, more a question of experience gained by practice. Nori will even out the paint, giving a smooth colour print. If your print is speckled and blotchy, you need more nori. Achieving a balance is a very common problem in early prints. Follow the steps and advice below and you will soon learn how to balance your paint and nori.

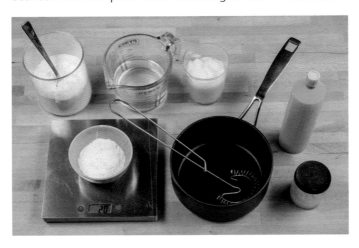

Equipment and rice flour for making nori on the left with commercially made nori in the tube and jar to the far right.

Nori Recipe for Printing

One part rice flour to ten parts cold water (by weight) will give a thick nori paste which can then be diluted to your liking with water when you come to print. Twenty grams of flour will yield enough nori to fill an average mug. Any standard white rice flour will work for this recipe, but avoid glutinous rice and wholegrain rice flours.

- Add the cold water to a pan and beat in the rice flour until the mixture is smooth.
- Allow the mixture to come to the boil, stirring or whisking continuously.
- Boil for three to five minutes, still beating, until the nori is smooth and thick.
- Remove from the heat and pour into a container. You will be dipping a chopstick into the nori to apply it to the block, so a tallish vessel is best.
- Top with plastic film or similar to prevent a skin forming over the surface.

Fresh nori will keep for two or three days in the fridge if needed. Nori that has spoilt will become slack and watery. You will need to make a new batch if this happens. It is not suitable for freezing.

Printing Brushes

The use of printing brushes is essential to Japanese woodblock printing. For good results, printing brushes should be made of natural hair, firm and springy in texture with the ends soft and split. The job of print brushes is to blend the paint and nori into a thin, even coat of colour across the block. Think of using these as massage brushes rather than handling them as paint brushes when you come to print.

Japanese print brushes come in two different styles, either with a long handle (*hanga bake*) or resembling a shoebrush (*maru bake*

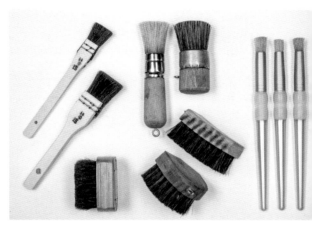

To the left is a selection of traditional brushes with dark horsehair bristles. In the centre and to the right are cut-down shoebrushes, stencil brushes and trimmed paint brushes.

or *burashi*). In the West the most readily available brushes are made of horsehair, but deer hair, hog bristle and the soft hair from a horse's winter coat are also used. These brushes are available in different sizes. You will either need to wash your brush between colours or own several as each colour requires its own brush. It is also possible to improvise print brushes. Natural hair shoebrushes or stencil brushes work, as can paint brushes when trimmed to give a flattened top.

Most printing brushes sold in the West come with their bristles ready-softened for printing, but if you are using an improvised brush, or feel your print brush is too hard, you can soften the bristles in the following way:

- Soak the brush bristles for an hour and then dry gently.
- Place a baking sheet or pan over heat and press the brush gently down to singe the end of the bristles.
- Bind the bristles with string to prevent splaying and then rub the brush hard against rough sandpaper until the brush is soft. In

Japan shark skin is used, but sandpaper or rough concrete will substitute.

* Wash the brush thoroughly before using.

A belt sander is a quick way to soften a large brush, but be very careful and check the brush frequently.

A selection of barens. To the left, a traditional baren showing its interior, its old cover, which has been removed, and a bamboo leaf for making a replacement cover. On the right, from top to bottom, two ball-bearing barens, a plastic baren and a cheap 'student' baren.

Baren

A baren is a disc-shaped tool used to take an impression from the woodblock by rubbing the back of the printing paper. Barens are available made with traditional bamboo, at varying costs depending on quality. Plastic barens and barens containing free-rolling ball bearings are also available.

It is best to use a sheet of baking parchment between the baren and the printing paper when printing to act as a buffer and to reduce wear on the paper.

A traditional baren is made in three parts: the backing (*ategawa*), a coil of twisted bamboo leaf (*shin*) and the bamboo cover (*baren-kawa*). Because of the complex construction, a traditional handmade baren for a professional printer can be extremely expensive, but its backing and coil will last a lifetime, with the printer replacing the bamboo cover as needed. Barens like this come with differing internal coils depending on their task, with coarser coils for heavy work and light fine coils for delicate detail printing. Professional printers will own a selection of weights.

Choosing a Baren

At the time of writing it is possible to buy a decent baren with a bamboo coil for about £50 in the UK. You may be able to buy two in different weights: a *beta* baren for general printing and a *sumi* baren for more delicate work. These are sensitive and useful barens and are the ones I use myself, along with a ball-bearing baren. There are also very cheap 'student' barens available in the UK, retailing for under £10. These are very basic tools and will not wear well, but will do for a first foray into printing, really just to see if you want to pursue the process.

You can prolong the life of a bamboo baren's shin by sliding it round from time to time to even out the wear. It is a good idea to lightly oil the

bamboo shin with camellia oil regularly and to sit it on a soft cloth for protection while printing and for storage.

Plastic barens are available either as an economical solid unit or a more expensive version with a plastic face that can be replaced as the baren wears smooth. Either will work well, be hardwearing and surprisingly good to use.

A ball-bearing baren is a substantial investment and works best with heavy papers and large prints. If you can, buy one that can be taken apart for cleaning, as paper fluff will inevitably build up inside it, clogging the baren and hampering the ball bearings.

Conditioning the Wood and Taking First Proof Prints

A new woodblock is like a newly plastered wall: it is very absorbent and needs to be conditioned by use before it prints well. In addition to conditioning the wood, it is useful to begin printing by taking a very basic proof print, working through all your blocks and printing one layer of flat colour with each block, resulting in a complete print on one piece of paper.

While this early print will look feeble and flat in colour, it will allow you to see if you need to correct your registration or if you need to cut away more clearance around any block. It will also give you a much better idea of how the finished print will look, allowing you to make adjustments to colours and to think about shadings and other effects that might improve it. Further test prints can then be taken until you are confident about colours and the steps needed to arrive at final prints.

You will need:
- A damp pack with several damp sheets of proofing paper cut to the correct size. This could be lining paper or an economical paper like the Fabriano Academia HP 200gsm mentioned earlier.
- Pots of paint mixed in the colours you would like to try.
- A pot of nori and a single chopstick.
- A selection of cheap brushes for mixing paint and adding paint to the blocks.
- Printing brushes.
- A baren and a sheet of baking parchment.
- A couple of rags (old towels are best).
- Some newsprint big enough to use to take 'trash prints' from a single block.
- Water for damping.

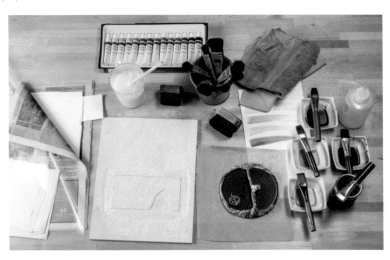

Assemble all the materials you need for printing before you begin. This will help your printing run smoothly.

Conditioning the Block

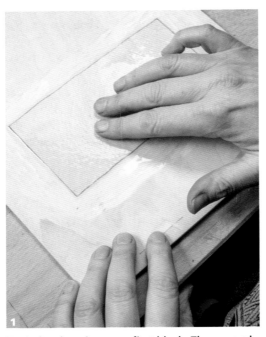

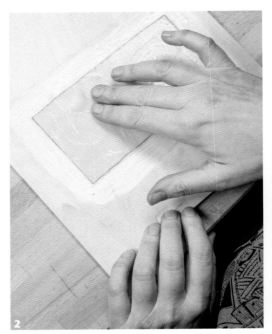

Begin by choosing your first block. The general rule is to work from light to dark and certainly where any blocks overlap, you will need to print the paler under-block first. If you have a key block that outlines other blocks, this is printed last. Damp the block thoroughly with water and leave to soak for several minutes (only damp the block you are working with, not the whole sheet of wood). The block *must be damp* whenever you are printing. The act of printing will keep it in a perfectly damp condition, but if you take a break you may have to re-damp the block before printing again. Damp one of your rags and blot away any excess water from the block without drying the wood.

With a new block you can 'condition' the wood, effectively priming it to print well, by rubbing nori into the block. This is a trick I adopted while teaching short workshops where quick results were needed. Rub in a coating of nori, using your fingers, and leave for a few minutes before wiping away the excess with your damp rag.

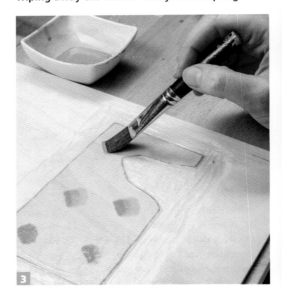

RIGHT: Take your paintbrush (not the printing brush) and wipe off most of the paint against the side of its pot. It is essential that you control the paint. Apply a few scanty dabs. The key to printing is not to overload the block.

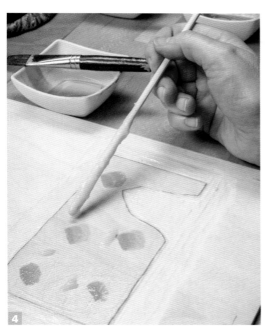

Take the chopstick and apply a similar amount of nori using the side of the chopstick. There is no exact balance for this, but begin at fifty-fifty and, as you practise, you will gain a feel for the balance of nori to paint.

Tilt the block to the light. The block should look as though it has been given a smooth layer of varnish, no wetter. If you have missed any part of the block, it will show up as a matt area.

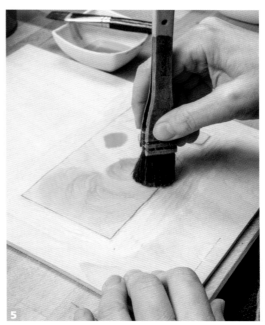

Take your printing brush and, holding it low on the handle if it is a hanga bake, keep the bristles in contact with the wood and work in small circles over the block to blend and spread the paint and nori. Once the two are spread and blended, brush gently over the surface to even it out. You will need to apply paint and nori to the block each time you take an impression.

With a new block you will need to take at least a couple of 'trash prints' to drive colour and rice into the wood to condition it. Place a sheet of newsprint over your inked block and rub with your hand to take a print. Do not bother with registration or a baren, and don't worry about the result: trash prints merely benefit the block, not your printing. Assess your result by the proof print, never by your trash prints.

Taking a First Proof Print

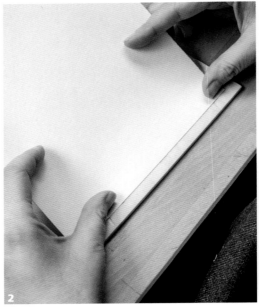

After the trash prints, ink up as before, this time to take a proof print. Now you need to hold the paper properly to place it accurately in the kento slots. Take a sheet of paper from your damp pack and use the forefinger and middle finger of either hand to hold the paper fairly low down, as though your fingers were scissors cutting the paper. This leaves your thumbs and other fingers free.

Slide the paper into the corner kento, taking your time to position it precisely, then put your thumb on the corner to hold it in place while you place the paper into the straight kento. Place your other thumb on the paper at the straight kento and allow the paper to fall into place over the block. Resist the urge to pat it with your hand: this is very likely to put unwanted marks on the paper. The paper will stay in position, held by the general dampness.

LEFT: Take the baking parchment and place over the printing paper. Hold your baren so that your hand is a flat weight on the tool, giving an even pressure when rubbing. Rub the block in a zigzag pattern at first and then switch to a circular movement to take the print. If you are holding the baren properly, your arm will be engaged from shoulder to hand. You need to exert firm, but not hard pressure. The amount of pressure needed will vary depending on the block (large flat areas needing more pressure and detailed blocks needing less) and paper (thin and/or washi papers being more sensitive than heavy and/or Western papers). As with much of Japanese woodblock, you will learn to use the correct pressure for your paper through practice.

Remove the paper from the block and check. Ideally you will see a neat sheet of flat colour, but don't be discouraged if this isn't the case. Refer to the troubleshooting section later in this chapter and try proofing again on a new sheet.

If you are using Western paper, you may see a slight sheen of unabsorbed paint on the surface of the paper, not to be confused with the messy excess of too much paint. This is easily blotted using clean newsprint before the print goes back in the damp pack.

RIGHT: Return your print to the damp pack. If you have more than one print, place in a staggered stack to even out their moisture. There will be no paint transfer provided there is no surface paint on the print to transfer to other prints or onto the damp pack. When you have a smooth sheet of even colour move on to the next step, but please don't get too hung up on perfection. You will improve as you go. Don't forget to return your proofing paper in the damp pack between printings.

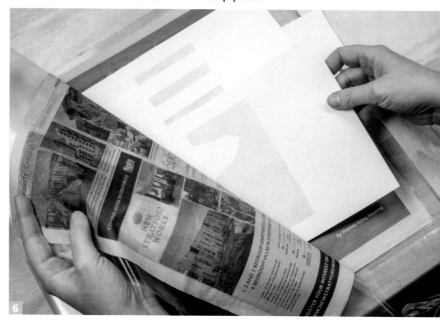

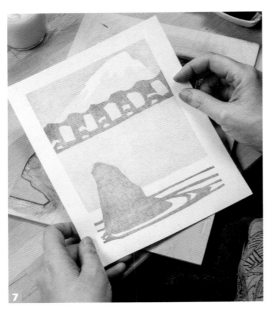

LEFT: Move on to your next block and repeat the process, printing your next block on to the same piece of proofing paper as your first. If you've had several attempts, use the best. Continue until every block is printed and you have a complete proof print on one sheet of paper and can assess yuor work.

BELOW: Practise your printing on more proof paper to become comfortable with printing, perhaps trying proofs in different colours. The more you use the blocks, the better they will print.

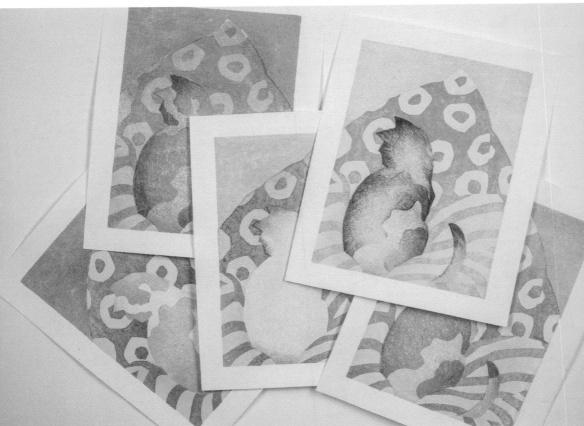

Changing Colours

It is possible to change your colours at any time while printing. Bear in mind that colours will seem weak during early printing. You can rinse off the paint in water alone for a subtle change of colour, or wash the block with soap and a gentle brush for a more drastic change. Take a few trash prints until the block is printing cleanly with the new colour. Unless you are changing colour, there is no need to wash off your block between uses or when storing.

Some Essential Tips

- Always use the largest brush you can handle for your block. The smaller the brush, the faster it will fill with paint and need washing and drying.
- Always keep your print brushes as dry as possible, using a dry towel to dab them dry at first (it is best to have two rags, preferably towelling: one for the block, one for the print brushes). Once the brushes become too wet for this process, you need to wash and dry them. A wet printing brush is useless as it merely sloshes paint and nori about.
- Remember that a block ready for printing should only hold enough paint and nori to look varnished: any more is too much. If you want more colour, take a print and then repeat to double print the block. Imagine your block is a glass of water: it can only hold so much liquid before it overflows. It must be emptied before you fill it again.
- If you adjust the proportion of nori to paint in order to improve the print (see 'Troubleshooting the Printing Process' below), it is crucial to reduce the volume of one to balance the increase of the other. If you do not make this adjustment, you will be adding too much liquid to the block.

- Always keep your printing paper damp by replacing it promptly in the damp pack every time you print and keep the damp pack tidy to retain its moisture.
- If you are moving on to a new block and your paper is in danger of overlapping with a previously inked and still wet block, either dry the damp block thoroughly or use newsprint to cover it to prevent transfer. Dry blocks will not transfer colour to the print.
- It is so easy to lose track of time when printing and become tired without realizing, while mistakes creep in. Try to take regular breaks. Simply having a stretch and tidying up the printing area regularly will help you to avoid becoming too weary to focus and prevent mess from building up: these are both factors that make good printing difficult.

Goals for This Chapter

By the end of this chapter you will have assembled the equipment needed to begin printing. You will have at least one completed proof print using all your blocks.

- You will have chosen your paints, baren and brushes for working.
- You will have decided the order of your blocks for printing.
- You will have conditioned and then proof printed each block in turn to arrive at a proof print with all blocks printed onto one piece of paper.
- You will have referred to the troubleshooting section if needed to improve the print.
- You will have practised printing to learn how to balance the paint and nori and how much pressure to use.

Troubleshooting the Printing Process

Look very carefully at the illustrations here, as they depict the problems that you are likely to encounter; remedies are suggested below each picture. For registration errors, *see* Chapter 3.

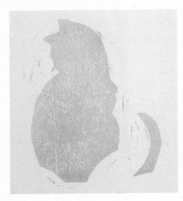

Unwanted printing from the trench area
- Allow your block to dry and cut away any unwanted high points or missed areas in the trench.

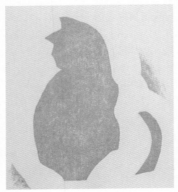

Unwanted printing from outside the trench
- Cut away a wider trench to accommodate your brush.
- Focus on keeping the brush within the trench, wiping any spills dry before taking the print.

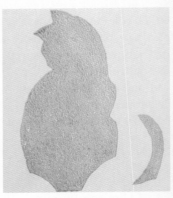

Poor impression or soapy looking paint surface on paper
- Not enough pressure: adjust the pressure with the baren, taking care not to go too far and crush your paper.

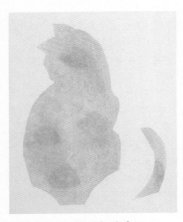

Staining on the block from inking
- Wood may 'grab' the paint on contact when you first ink up and then stain, leaving blotchy areas that may transfer to early prints. Keep printing. The blotches will disappear as you work, so don't be tempted to wash the block.

Areas of weak or missing colour
- Uneven inking and missing areas when inking: focus on your brushing technique when inking up the block for printing. Check by tilting the block to the light, ensuring it is fully covered and appears shiny with no obvious brush lines.

Surface of the paper lifts or paint looks textured with a 'crushed' appearance
- Too much pressure: adjust your pressure with the baren.
- Delicate papers can be strengthened and papers with loose fibres improved by a coat of size, if baren pressure is not an issue.

 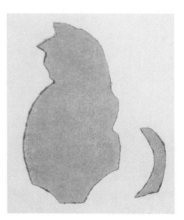

Clear white marks in printed areas

- Block surface dented: Try soaking the block or apply gentle steam heat from an iron to the surface through a cloth, either may help the grain to swell back.
- Get into the habit of covering the underside of the block with paper or cloth to protect it while you cut the top. Store carefully: see Chapter 8.
- Registration errors See Chapter 3.

Grainy or speckled colour

- Lack of nori is the most likely problem. Rebalance your quantities, reducing the paint and adding more nori when you print. It is possible to improve this problem on the current print by reprinting the block either with paint and nori, or just using the nori paste.
- The block is too dry: allow the wood to soak up water before printing again and pull a trash print to ensure it is damp enough to print properly.
- The block is new: as the pores of the wood absorb rice and colour, printing will improve.

Blurry edges and clogged up details

- Too much paint and nori on the block: you may be able to save the print by blotting. Remember that the block should look varnished, no more.
- Wet printing brush: the excess paint is no longer removed from the block. Replace the brush with a clean dry one.
- Fine detail too shallow: although Japanese woodblock is very sensitive, there comes a point where cut marks are too shallow to print. Recut a little deeper.
- Block edge undercut in error, enabling paint pooling: you can't correct the cutting at this stage, but at the next printing take care to wipe away any paint pooling at the edge of the block.

Troubleshooting the Printing Process (cont'd)

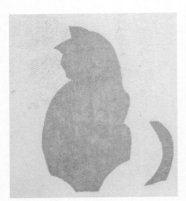

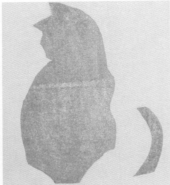

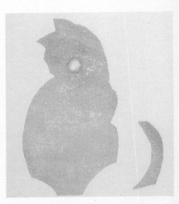

Transfer of paint from another print

- Wet surface paint from other prints in the damp pack transferring to the print: always check there is no surface paint on prints when returning to the damp pack, blot with newsprint if necessary.
- Paint transfer from the damp pack: if the paint is on a newspaper damp pack, remove the offending sheets of newsprint. If it is on blotting paper, refold the damp pack to avoid the area.
- Pressure transfer: a common mistake is to use the damp pack as a surface to rest prints on while blotting. Ensure you have another area available for blotting when you set up.

Paper refuses to absorb paint or absorption is uneven

- Over sized paper: too much size/dosa has made the paper water resistant. Double printing and increasing pigment strength may help.
- Unevenly sized paper: the uneven surface absorbs paint at different strengths. Begin again, checking carefully for even coating when sizing.

Irregular blotch of white or paler colour in the printed area

- Lump of nori pressed into the paper while printing: this cannot be corrected once printed. Always cover the surface of freshly made nori directly while it cools. This prevents a skin forming which can lead to lumps. If in doubt, strain fresh nori through a sieve before covering and cooling. Check for lumps regularly when printing.

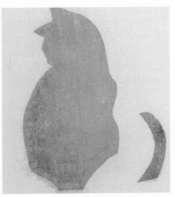

Paint bleeds at the edges of the impression

- Paper too wet: adjust your damp pack and paper by opening it and blotting to reduce moisture.
- Paper needs sizing. See Chapter 5.

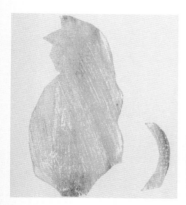

Brush marks showing
- Check the brush for overlong hairs and trim away using scissors. Never pull long hairs from the brush.
- Brushing technique: be sure to brush over the block gently to even out the paint surface before printing.
- Too much nori: try reducing the nori and increasing the paint.

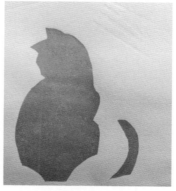

Embossing from other blocks or from the trench
- Embossing from other blocks: pad the edges of near-by blocks with a couple of layers of masking tape to temporarily soften the edge.
- Edges of your trench embossing: smooth the edges over with a chisel.

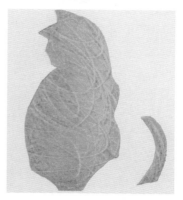

Random curving lines in the printed area
- Grit in the baren making marks: check the baren's surface is entirely even and remove any grit.
- Edge of the baren making marks: check you are holding the baren correctly.

Difficulty placing the print flat in the kento, loss of registration
- Paper drying out: return the print to the damp pack and check the pack is damp enough. Leave the print to re-damp before printing. Always return the print to the damp pack as quickly as possible.

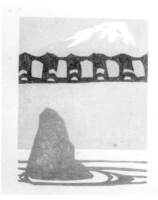

Unexpected speckles or blotches of colour
- Mould growth: dispose of all affected paper and the damp pack and start from fresh. See Chapter 5.

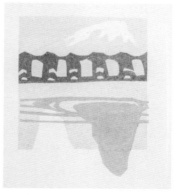

Block appears in the wrong place
- Using the wrong kento: cover any kentos that you won't be using with masking tape.
- Paper incorrectly orientated: put a pencil cross on the back of the printing paper marking the kento corner.

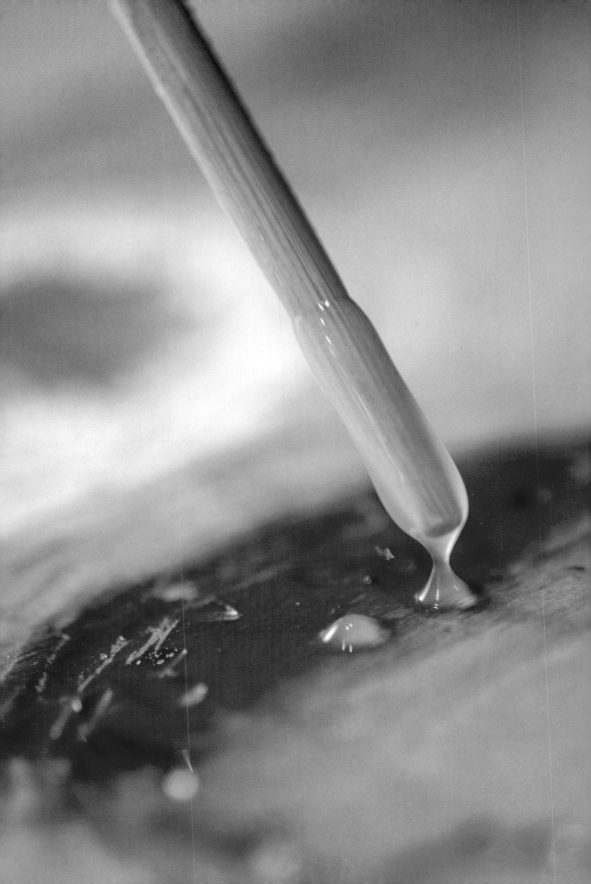

SHADINGS AND OTHER PRINTING TECHNIQUES

While learning to print flat colour is a skill in itself, additional printing techniques will bring your print to life. The most familiar effect is the subtle shading of colours from dark to light called *bokashi*. In this chapter you will explore further printing techniques to enrich your print. Strictly speaking, some of these techniques will enter the realm of monoprinting, but when printing in the rhythm of editioning, it is possible to keep prints fairly uniform.

Double Printing for Bold Colour

Double or even triple printing is a valuable tool for enhancing your print; it allows you to build colour intensity without altering the colour in the mixing pot. It can be useful to double print in the early stages of working with a new block, while the block is still absorbing the colour. It is a very effective method when printing yellows, or subtle colour blends where you want intensity rather than a change of shade. Double printing can also change a colour: a sheet of blue will turn green if the block is printed again with yellow paint in place of the blue. Harsh colours can be

OPPOSITE PAGE:
Nori is added to the block using a chopstick.

From bottom right to top left, a print with a single colour layer, a print with a double layer of the same colour and a print showing its original colour plus a different colour layer added on each side.

balanced judiciously by a second printing of a colour designed to knock back the first. Double printing with nori alone will help to even out colour where there is texture in the first layer printed.

Bokashi

The term bokashi means 'graduated shading' and is a key technique in Japanese woodblock printing, bringing the print to life and giving it dimension. In traditional printing there are many variations of bokashi, including ways of cutting the block to create a bokashi effect. Below are three ways of creating a bokashi, one from the edge of the block and two from within the block.

Bokashi are printed over paler flat colour as a rule, but can also be printed alone, leaving the block partially printed with a shading only. They can be printed in several layers, beginning with wider pale bokashi, adding deeper and narrower bokashi on top. When mixing paint for a bokashi, err on the bold side: it is frustrating to go to the effort of printing a bokashi only to find it has vanished into the previously printed colour!

It is essential when printing a bokashi that one side of your brush holds the paint and the other side remains clean. Either mark one side of your brush or put a bit of tape on it, so you will know which side holds the paint. If your brush is evenly covered in paint, it will not create a bokashi. Work with as wide a brush as you can for the area to avoid overloading. You may like to take a couple of trash prints before going on to printing paper to prepare the wood and check the width of your shading. A good bokashi takes time to master. The commonest mistakes are to apply too much paint and not to keep the brush divided into wet and dry sections.

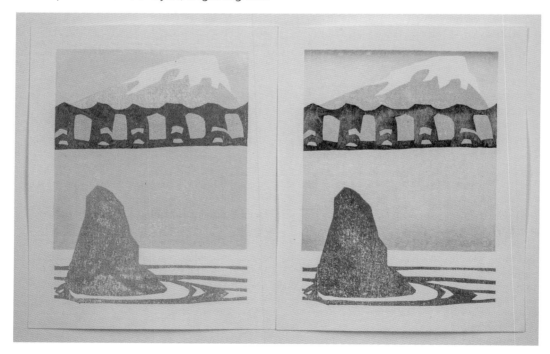

This print comes to life with the addition of several bokashi layers.

Bokashi from the Block's Edge

Make sure your block is damp and ready to print. Keep a very damp cloth at hand as the block must be wiped clean and made damp between each bokashi. Apply your colour in a strip along the edge. The wider the band of paint, the wider the bokashi. Always apply paint in a strip when making a bokashi as this makes it easier to pull out the bleed of colour. Use a paint brush, not a printing brush. Turning the block to a better angle for applying the paint can be helpful.

Add nori in small dots along the strip of paint using the end of the chopstick.

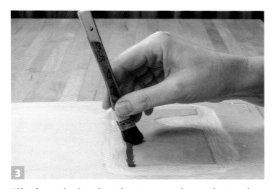

Tilt the printing brush at an angle so that only one side of the brush is in contact with the paint and work it gently from side to combine the nori and paint. A piece of tape on the brush shoulder will remind you which side holds the paint.

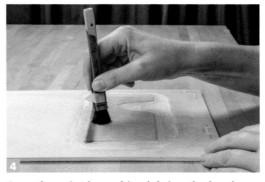

Once the paint is combined, bring the brush upright and, keeping the bristles in contact with the block, work in tiny continuous circles across the bokashi area to coax the paint to blend into a bleed of colour. If your bokashi is very narrow, use a side-to-side motion rather than circles, but keep the brush on the wood.

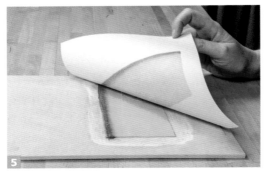

Check to see you have no hard edges or loose paint. If your paint won't move and blend, add a fraction more nori. The bokashi should look soft and well graduated on the block, ready to print.

Once the impression has been taken, wipe the block ready for the next print.

Bokashi from within the Block

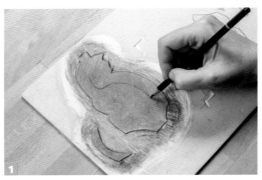

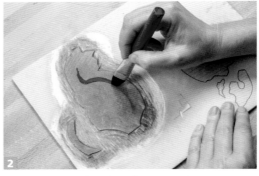

It may help to draw a guide line on your block in pencil or with carbon to make positioning your bokashi more consistent. Neither mark will transfer to the print. Wet the block as before.

Apply paint and nori to the area where you want the shading to be, either as a shape that you can tease out into a blush of colour with gradated edges all round or, as here, in a strip of colour.

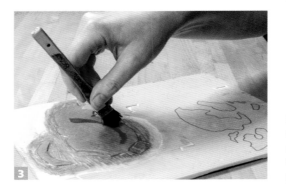

If, as here, you want to preserve one hard 'false edge' on the block, begin working the brush as before, but keep the paint-heavy side of the brush from straying over the edge of the painted strip, and work to create a gradation.

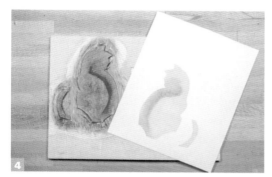

Example print showing bokashi from within the block. Remember to wipe your block to clean and damp it before printing again.

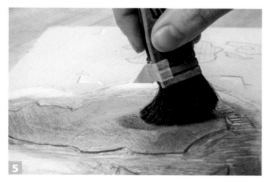

To create a bokashi with a completely gradated edge, work your brush around the shape, maintaining one side in the paint and one side dry, blending the colour into a bleed as you go.

Example print showing circular bokashi. Remember to wipe your block to clean and damp it before printing again.

Blending Colours on the Block

Not to be confused with bokashi, this method mixes one colour into another on the block and is useful for creative printing for transitions of colour or creating texture.

When choosing colours for blending, bear in mind that a good contrast between them, either of colour or of tone, will give the most effective result. You will need a clean print brush for each colour. Remembering to place the correct print brush beside its colour as you work is a good habit when printing blends.

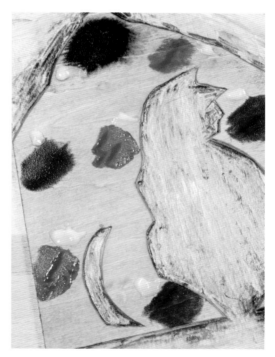

Place the colours on the block where desired, either randomly or in strips. Add nori, ensuring that every area of paint has its own supply. You are likely to end up with a little more paint and rice on the block than you would for a flat colour layer. This is better than too little as you'll need to work the colours more for a blend. Your print brushes will remove the excess, provided you keep drying them.

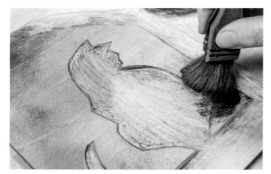

Using one brush per colour, gently work the colours into the block and each other. The more you work and blend the colours, the softer the transition from one into the other. If the paint seems 'stuck' add more nori to lubricate.

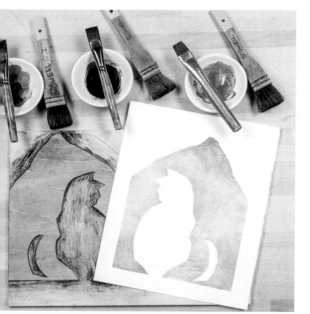

Take the print when the colour appears well blended and there is no loose paint or nori on the block.

Goma-zuri (Sesame Seed/ Speckled Paint Printing)

Printing with too little nori results in a speckled or blotchy print. While this is generally considered a fault, it can also be a useful effect, adding a contrasting texture to the print. The print is inked up as normal for printing, but far less nori is used. The results are very dependent on the amount of nori used and the printing paper so you will need to experiment to arrive at the result you want for a particular print.

Baren-suji (Monoprinting Effects with Baren)

As with goma-zuri printing, baren marks are usually seen as a fault, but can form a decorative texture in flat paint if desired. You can practise using the edge of the baren to rub the paper, but a more controllable answer is to buy a cheap student-grade bamboo baren and slip a very small piece of grit, without sharp edges, under the bamboo cover. This will give you a more uniform effect.

Monoprinting Effects with a Brush

It is possible to catch the texture of a brushstroke when printing, but this is truly a monoprinting method, not to be confused with cutting the woodblock to simulate a brushstroke as discussed in Chapter 9. For this technique, take a cheap coarse brush and dab the end into dryish paint (as though you were going to stencil). Sweep the brush over the block to make a stroke or flick it over the edges of the block to make

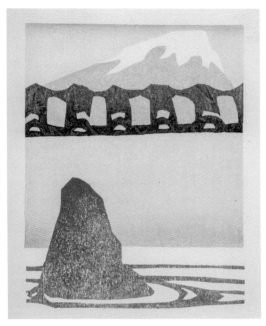

Goma-zuri printing used in combination with flat printing enhances the rock in this print.

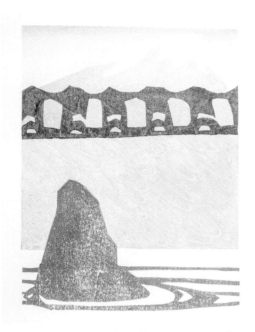

Baren-suji: baren marks add movement and interest to an otherwise flat area.

Monoprinting effects: this paint effect takes practice, but can be very striking if used well.

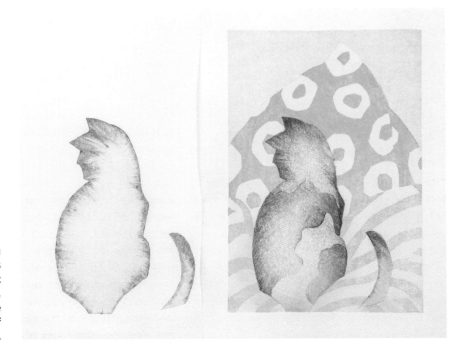

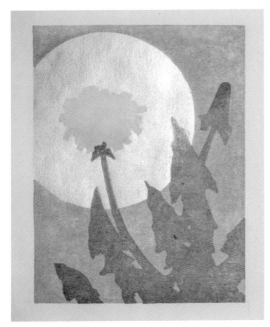

Kira-zuri: traditionally mica is often used on the background area of a print and adds a rich lustre.

a textured outline. Take a print directly without adding nori or blending with a print brush. The brushstrokes will always be softer on the print than they appear to be on the block.

Kira-zuri (Printing with Mica)

When using mica powders, do *be careful not to inhale the dust*. Mica is available in a variety of colours from fine powder to coarser flakes. It is usually applied to the print as the final stage of the printing over a printed colour, fixed in place with a layer of glue. The simplest glue is liquid gum arabic. I find it works best to use a stencil to protect the print when applying mica. It can also be blended into your paint for printing, but the effect is much more subdued.

- Cut a stencil in plastic, card or stiff paper to isolate the area you want to treat from the rest of the print.
- As mica is fairly transparent, print a flat colour on the block to give yourself a base.
- Apply a layer of liquid gum arabic to the block with a printing brush and take a print. It is important that you are gentle with the baren as you want to deposit the gum arabic on the surface of the paper, not drive it into the paper fibres (especially when using washi paper). You can tint the gum arabic with colour if you wish.
- Lay your stencil over the print, not the block, and apply the mica by shaking it over the damp area with a fine sieve. Using a soft brush, gently work the mica onto the paper. This removes the excess mica and fixes a layer into the glue. Be very careful not to disturb the stencil or gum arabic.
- Collect up the excess powder and use for the next print.
- Wash the block with water. This will remove the gum arabic, returning the block to its original condition.

Over-sizing, or Selectively Sizing, Paper with Dosa

Dosa (size) affects the porosity of the paper and it is possible to exploit these water-resistant qualities to manipulate the way that paint lies on the paper. If a stencil is used or the paper is selectively masked and then the dosa applied as usual, the finished print will have areas of differing absorbency and paint will be taken up in differing ways.

I sometimes deliberately over-size a sturdy paper by adding an extra coat of dosa. Printing on such paper requires much more effort, both in double and triple inking to build colour and extra pressure with the baren with the paint effectively smashed through the dosa into the

Private Woods. Many layers of printing at a strong pressure were needed to create this grainy print on strongly-sized Fabriano Rosaspina paper.

paper. The end result is a print with an all-over grainy appearance rather like analogue fast film, quite different from goma-zuri.

Kara-zuri (Embossing)

Kara-zuri translates as 'empty printing' and involves pressing the print paper onto the block to create embossing with no colour. It is a subtle technique and works best using a heavy paper with the final result showing under a raking light. Embossed areas of a print need to be printed last, ensuring the rest of the printing does not flatten them.

- To emboss the paper with a block, use a thick paper and damp as usual.
- Damp the block (the block must be clean of paint) as this will prevent the paper slipping; there is no need to condition the block with nori or to use nori while embossing.
- Take a print from the bare block using strong pressure.

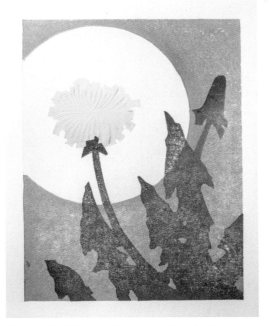

Kara-zuri: this is a subtle technique best revealed by raking light, seen in here in the flower. It adds sophistication and an unexpected element to a print.

EDITIONING AND FINAL PRINTING

Printing multiple final prints or an edition of your print onto good-quality paper with your best materials can seem daunting, but with good preparation it is a very satisfying and enjoyable process. In this chapter you will learn how to approach a final printing, along with tips about the drying and care of finished work, brushes and blocks.

OPPOSITE PAGE: **Numbering and signing a finished print edition.**

While proofing and testing, your print requires you to hop from block to block, perhaps only taking a single impression from each before moving on. Editioning or multiple printing allows you to work on blocks in turn with every piece of paper receiving the same layer of colour before you move on to the next layer or block. This repetition will mean your blocks will be working at their best, conditioned by the continuous printing to be at peak condition. You will also find this a more focused and

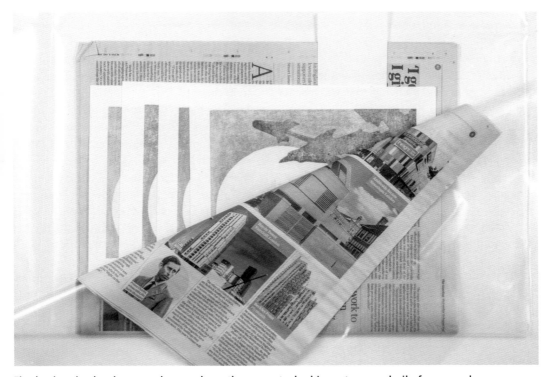

Final prints in the damp pack; note how they are stacked in a staggered pile for even dampness.

easier process to manage; with good preparation multiple printing can become an efficient rhythm, almost a dance.

Time Management

Having time to focus and work uninterrupted is key to multiple printing, especially with your best materials. Japanese woodblock prints have no drying time between layers and the blocks reach their optimal dampened state by uninterrupted printing. If time is short or your print very complex, you can make the following compromises:

- Short break: prints can be left in the damp pack or frozen. To freeze, wrap in plastic and lay flat in a freezer. Allow to defrost before printing.
- Break of more than a few days: prints can be dried and redamped mid-printing if needed. You will get better results from the blocks if you print a few layers across all the prints and then break, rather than printing all the layers on a few prints and then going back to repeat the process again.
- Long break: prints can be printed in batches to complete an edition. When your print is complex or the edition size large, prints can be done in batches and the blocks stored until needed. Keep a swatch of samples and notes detailing your paint colours and store the blocks unwashed. *See* 'Storing Your Blocks' later in this chapter.

Sacrificial Prints

It is a good idea to prepare additional printing paper to act as sacrificial prints. As you will have learned by now, there's many a slip between the start and finish of a print, so it is best to allow for some wastage. Inevitably the first prints will not be as good as later ones since printing blocks take time to reach optimal condition before printing at their best. In addition, you may find yourself calmer with a couple of trial runs before you commit to the final prints. Sacrificial prints can be proofing paper, but use at least one sheet of the paper you are using for the final printing. If you make a mistake on one of the final prints, move it to the front of the printing order to become a sacrificial print. It is personal choice how many sacrificial prints you want to use; balance your confidence against the work of extra printing. I suggest two as a minimum.

Preparing to Print

- Paper can be organized in advance by cutting and damping the day before, as can the nori.
- Make sure your printing station is organized with all the tools you need to hand and is comfortable to use whether you sit or stand to print.
- Mix the paints you need in advance, unless you are very confident about controlling colour, ensuring you have enough for all the printing ahead.
- Make sure you have your proofs and any notes you need about shadings or effects to hand for reference, but don't be afraid of changing things if you feel you can improve the print at this stage; you have sacrificial prints to check if you are right!
- Put your blocks ready in the order of printing. Working from light to dark is usually the best as it helps to keep the prints and damp pack clean.

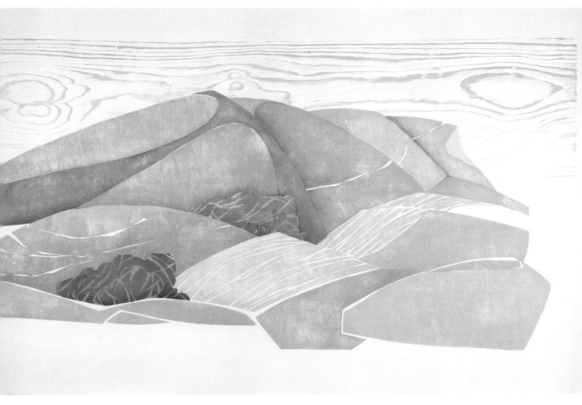

South Downs, Distant Hills. This print measures 1.2m (40in) across, with a scaffold plank used for the sky block. It was printed on Fabriano Academia HP 200gsm paper using the paper-rolling technique.

Working with Large Prints

As long as the printmaker can place the paper accurately for printing and maintain its dampness, there is no real barrier to the size of the print in Japanese woodblock printing. Large prints do not require any alteration in the cutting or registration methods; your kentos will simply be much further apart. Maintaining the dampness of the paper is critical. Your damp pack should be of blotting paper for its larger size and stable dampness.

Holding the paper to place in the kento is key! Here are two methods:

1. Medium-size paper: gently bend the top of the paper over towards you to meet the bottom edge. Be very careful not to crease it. Hold it double with your scissor grip to insert into the kento as usual, allowing the paper to open up onto the print.

2. Large-size or flimsy paper: with the paper face down, gently roll up the top of the paper towards you into a tube and place your fingers inside the roll for the corner kento and at a point along it for the straight kento. Position the paper in the kentos, hold the paper firmly in place at the kento, take a deep breath and allow the paper to unroll across the print.

Drying Prints

Once you have finished your printing, your prints will need to be dried flat. The act of damping and printing will have stretched the fibres, so the paper will be wavy if air-dried. Drying is best done in stages.

1. Place the prints between sheets of clean unprinted newsprint and place under a light weight (a tray or cutting mat) for an hour or two to remove some of the moisture.
2. Place the prints between clean cardboard or blotting paper, dividing the pile into one or two prints per layer if possible, and place a heavier weight (a tray plus books) on top. The weight should be well spread over the drying area.
3. Depending on the paper, it may take a few days for the prints to dry. Check regularly and swap the damp cardboard or blotting paper for dry if possible. Make sure your prints are perfectly dry, otherwise they may still cockle.

Large Prints

Large prints can be dried using the same approach, but replacing the cardboard or blotting paper with sheets of clean plywood (this can be from a DIY shop). Birch ply works well; just check the surface is smooth and clean, brushing off all sawdust.

Embossed Prints

Embossed prints can be dried without losing their texture by attaching the print to a board with gummed brown paper tape, as you might do to stretch watercolour paper. Use a clean board and gum the prints face down to avoid tape marks.

Flattening Prints Exposed to Damp

If your prints are exposed to damp or you remove them from their drying stack too quickly, they may go wavy. If this happens, follow the instructions for redamping in Chapter 5 and repeat the drying process.

Cleaning and Storing Your Brushes

Print brushes should be washed out immediately after use to avoid the rice setting hard in the bristles. Wash them carefully with mild soap, pressing the brushes gently against your palm, and rinse in fresh water until clean. Gently squeeze with a towel to remove moisture and then air-dry.

Hanga bake (long-handled brushes) should dry hanging with the bristles down. Maru bake (shoebrush-style) should be left to dry on their sides. Never leave them bristle side up as the water will seep into the wood and cause cracks. The best way to store brushes is to hang them up, so you may need to drill holes for strings or attach hooks. If you have to store brushes in a container, use breathable cardboard and make sure the brushes are completely dry before putting them away.

Storing Your Blocks

There is no need to wash your blocks after using, unless they have become clogged with paint and rice or you wish to change their colour. It is a good habit to make a note of the print's title on each piece of wood for reference. Blocks should be stored in a dry place without extreme changes in heat or humidity. They are

best stacked side by side like books, helping to protect their surfaces. If you need to layer your blocks in a pile, put a protective sheet of paper or fabric between each one to avoid damage.

Numbering an Edition

If you wish to produce a limited edition of your print, you will need to number and sign your prints. Do this as soon as the edition is dry, while all the prints are together, to prevent confusion over dates and numbering. The convention is to use pencil and to number each print in turn with the print's individual number over the total number of the edition, 1/20 etc., in the margin on the bottom-left corner of the print. Your signature and the year should go on the right-hand side of the print. If you wish to add a title, that goes in the centre, again in pencil. Do bear in mind when deciding on the size of your edition that, once an edition is limited and the total number of prints completed, you cannot print more of the same.

You can print artist's proofs in addition to the edition, marked 'a/p' rather than numbered. These are identical to the edition and were traditionally for the artist to sell or gift independently from galleries or dealers. Convention dictates that you should only produce a few artist proofs: ten per cent of the edition total is considered to be the maximum acceptable number of artist proof prints.

Storage and Display of Prints

Once dry, your prints should be stored out of the light to preserve their colour in a box, drawer or plan chest. Ideally, you should also interleave them with acid-free tissue to avoid them absorbing moisture.

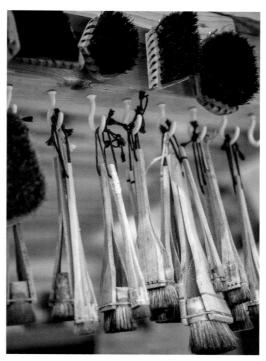

Hanging your beautiful printing brushes for storage benefits both the brush and the eye.

If you intend to sell your work, it is important to keep accurate records. You will need to know what you have in stock, whether it is framed and what work is out at shows and galleries.

Your Japanese woodblock prints can be mounted or framed behind glass to sell or display in the same way as any other print. However, some water-based pigments may be susceptible to change and fading if the work is exposed to bright light over a long period, so ensure they are not hung in direct sunlight. Using the best-quality paints and pigments for your final printing will ensure that your prints are as colourfast as possible. Advise any clients to hang your prints as they would a watercolour painting.

You may also consider using art glass in your framing. It is more expensive than conventional picture glass, but will protect the print from light damage to an extent and has anti-reflective qualities that improve the viewer's experience.

ADDITIONAL CARVING TECHNIQUES AND TOOL SHARPENING

Wood Grain Printing

The Japanese woodblock technique is ideal for capturing the detail of wood grain. It is sensitive enough to pick up fine detail and, since no printing press is involved, the wood can be a little uneven. Any unsealed wood flat enough to print with a baren or the pressure of your hand is viable, with cheap woods like pine often giving the most dramatic grain. Keep this effect for large simple blocks as the uneven wood can be hard to cut precisely. Don't be put off by rough edges, knot holes or bark; all can add character to the print. To print well, the grain of the wood should be pronounced. This is best achieved by burning

OPPOSITE PAGE: **A blowtorch burns away soft areas of the wood to reveal the harder grain.**

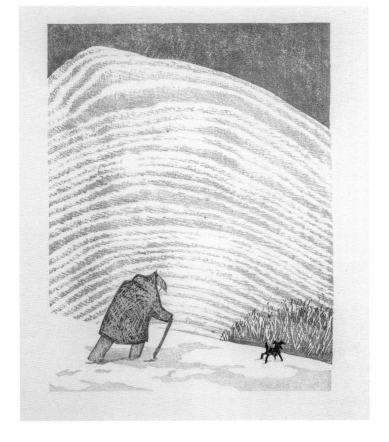

The Daily Walk. **A wide plank of elm provides the snowy mountainside in this print.**

the wood with a blowtorch and wire brushing in the following way:

- Depending on the size of the wood, either rough out which area you want to use with a marker pen or treat the whole piece.
- Find a safe, well-ventilated area to work. Move any flammable items well away and remove any trip hazards. Equip yourself with appropriate protective equipment for your eyes, nose, mouth and hands. Make sure there is somewhere safe and stable to put the hot blowtorch down. A fire blanket is a reassuring, effective and inexpensive precaution.
- Using a hand-held blowtorch and working in slow even passes, burn the surface of the wood until it is black and cracks in lines. This takes a little time.
- Use a brass wire brush, choosing a size appropriate to the job. Avoid steel brushes as these may deposit metal flakes, leading to rust on the prints. Gently brush away the burnt soft wood, working in the direction of the wood grain, until the harder grain is revealed. Be careful not to add scratch marks to the wood.
- Wash the wood thoroughly with soap and water, scrubbing to ensure clean printing.
- Mark up, cut and print as usual. If you find the baren is not picking up enough detail, gently smooth your hand over the print to press down into the grain a little more.

Kasure or Sabitsuke (Carving to Mimic Brushstrokes)

Cutting your woodblock to mimic a brushstroke is a more sophisticated way of catching the energy of brush and ink than the monoprinting approach mentioned in the last chapter. This method makes it possible to print an edition with consistent results. It relies on using the hangi-to knife both as usual and in short jabbing cuts to simulate a random edge and takes a lot of practice to master. It is important to study just how the ink lies on the paper, making sure there is a good contrast in your cutting between smooth heavy areas of ink and fractured light areas where the ink breaks up.

Incorporating Kasure into Your Print

If you wish to incorporate brushstrokes into your work, it is important that their energy and movement flows in the right direction. This method allows you to reverse your brushstrokes for cutting to ensure a fluid result.

Using your master tracing as a guide and lining up the paper accurately for the kentos, map out the area to be occupied by the brush painting on a fresh tracing. Here the area for the kasure is marked in red.

2

Using your fresh tracing, map out the outline of the kasure onto your wood along with the kento guide lines as you would any other block.

3

Take a fine paper (lightweight washi paper, airmail or layout paper work well) and trace out the area you have mapped several times. Using a brush and sumi ink, brush paint your design as many times as you need to create a pleasing result, making sure your final choice aligns correctly to meet other blocks if necessary.

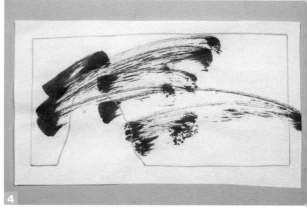

4

Cut out the best brush painting keeping the outline marking intact.

5

Put a little nori on the block to act as glue. Use the heel of your hand to spread the nori in a fine layer across the block. Finish by patting the nori gently all over with the heel of your hand.

Stick the brush painting face down to the block, matching the two guide outlines together as closely as possible. Either pat down carefully with your fingers, or run a baren lightly over the paper using baking parchment to protect it. Allow to dry completely before proceeding.

A little camellia or vegetable oil can be rubbed gently over the paper to improve its transparency for cutting.

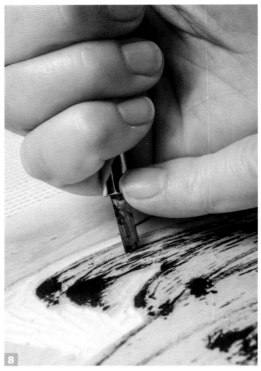

Cut the block following the paint lines as closely as you can. Use your hangi-to to break up the edges of your block with short stabbing cuts in contrast to the longer smooth strokes as you follow the brushstroke. Clear out a trench around the block and print as usual, paying careful attention to brushing excess paint from the block.

The brush effect is greatly enhanced by adding bokashi to the print where the ink would naturally have been at its heaviest.

Making a Jig for a Small Block

Occasionally you may want to use a block of wood that is too small to include your kento. This can often be the case for wood chosen for a decorative grain as you will want to orientate it to best suit your print, not the placing of your kento. The best way to achieve a consistent result is to build a jig to accommodate your block.

- Refer to your master tracing to choose a sheet of lightweight ply large enough to accommodate both the block and its kento, with the kento aligned at the edge of the ply sheet.
- Using timber or plywood that matches the thickness of the block you want to print, stick two strips of wood along the right edge and bottom of the ply using strong glue to form an L shape. The timber should be wide enough to accommodate your kento.
- Hold your master tracing on the timber strip to position your kento and slide the small block into the right place under the tracing. Remove the tracing without moving the block and draw around the block to mark its position on the ply.
- Stick the block to the ply, either permanently with wood glue or temporarily with strong double-sided tape.
- Replace the master tracing and transfer both kento marks and the block outline to the jig and small block respectively. Cut and print as normal. If the gap between kento and block is wide, slide a piece of wood between the two to act as a support for your paper.

This jig allows a small block to be positioned to make full use of its decorative grain.

Keeping Tools Sharp

Sharp tools are essential for ease and accuracy of cutting. It would be easy to dedicate a whole book to sharpening alone. In addition to the advice here, I strongly advise you watch some online videos on the subject.

There are two processes detailed here: honing, a polishing process for maintaining sharpness; and sharpening, a more aggressive process for reconditioning the blade. When learning to sharpen, it is a good idea to colour in the bevel of your tools with a permanent marker so that you can check you are sharpening correctly.

Day-to-day sharpness can be maintained using leather and honing paste. All new tools will benefit from this treatment too unless the

supplier provides them already honed, which is unusual. Over time this process will eventually round the tool over, requiring you to sharpen on a stone or film to flatten them again.

Honing on Leather

You will need a thick hard piece of leather. Part of a wide, sturdy belt from a charity shop stuck right side down on wood is ideal. You also need a tube of honing paste (sometimes called stropping paste or honing compound). This is a gentle method and will not raise a burr so you are working with the outside bevel of your tool only.

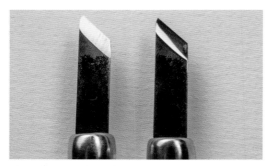

The blade on the left is new and has a satin appearance; the blade on the right is honed ready for use.

Always draw the tool firmly towards yourself when stropping to avoid cutting into the leather.

New tools will feel sharp, but they are seldom honed (polished smooth). Check the bevel where the angle of the tool changes at the tip and it is likely to look like satin due to tiny scratches forming troughs and ridges in the blade. The tool will stay sharp longer if you hone it before use, polishing the micro ridges to mirror smoothness. In daily use, tools can be stropped once you feel they are losing their edge; keep a scrap piece of shina ply to hand for testing the blade as you hone.

- Put a pea-sized lump of paste at the top of your leather and smear it across.
- Touch the tool down on the paste at the angle of the outside bevel and pull firmly towards yourself to polish the bevelled edge. Curved tools can be polished in stages, centre and sides, while V tools and the hangi-to should be polished at an angle to suit the blade. *See 'Sharpening' below.*
- Over time the edge of the bevel will round over. Honing will become ineffective; at this point you must sharpen with a stone. Further honing will just increase the problem.

Sharpening

For personal preference, I use two diamond-stones (600 and 1200 grit) in combination with a 4000 grit water-stone, adding slurry from a *nagura*-stone to all three as I work. The sequence photographs show the 4000 grit water-stone and the nagura-stone.

There are a variety of materials for sharpening tools alongside the traditional water-stones used in Japan. Do not use oil-stones in combination with water-stones as this will damage them. Never use a high-speed grinding wheel as it is likely to generate heat and damage your tools.

Water-stones

- Most traditional.
- Need to be soaked before use.
- Should be used with nagura-stone (mud-stone) which creates a fine slurry.
- Need to be rinsed and dried to prevent mould.
- In time, grooves will appear in the stone and it will need flattening with a diamond-stone.
- Can be damaged by tools digging into their surface.
- Prepared for use by soaking for half an hour and then rubbing the nagura-stone over the surface of the water-stone to create a slurry.

Diamond-stones

- Low maintenance: no grooves will appear, so no need to flatten; easy to rinse and dry after use.
- No danger of mouldcan be used with water only or, even better, with a nagura-stone.
- Cannot be damaged by your tools.
- Prepared with a squirt of water over the surface.

Lapping film

- Inexpensive, but must be attached to a completely flat tile or sheet of glass.
- Available in a wide range of gritsmust be replaced regularly.
- Easily damaged by your tools so you must work on the pull only.
- Prepared with a squirt of water over the surface.

If a tool is badly damaged, chipped or very rounded over, begin with a coarse stone. Otherwise begin with a medium stone, following the sequences shown in the pictures, and repeat using a fine stone. There is no need to hone the tool after using the finest stone. The effect is improved by using slurry from rubbing a nagura-stone over the diamond-stone's wet surface, but it is not essential.

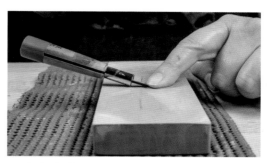

Begin by balancing your tool, here a hangi-to, on your stone so that the angle of the outside bevel is flat to the stone. As you practise sharpening, you will learn to recognize when you are in this position for each tool. When you hit the sweet spot, the blade will move easily and smoothly over the stone.

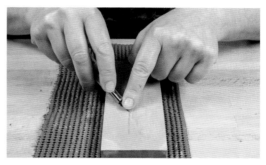

Hangi-to: place the bevel against the stone, pressing your finger on the back edge of the hangi-to and slide back and forth on the stone. Stop when the bevel appears uniform.

Check the reverse of the blade for a burr of metal. To remove the burr turn the blade over and lie it flat on the stone with the handle sticking out sideways. A couple of strokes will remove the burr.

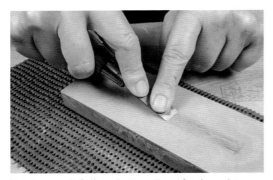

Kento-nomi: follow instructions for hangi-to keeping the edge of the chisel square to the stone.

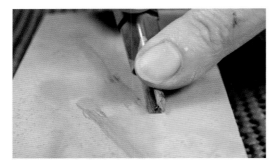

Sankakuto (V tool): treat this tool as two chisels that need to be sharpened, making sure that the two faces meet accurately at the centre of the V. Work slowly with constant checking. If there is a little point sticking out from the centre of the V once the sides are ground evenly, grind it off carefully like a tiny U gouge, rolling the tool over slightly to keep its angle at the same degree as the bevel.

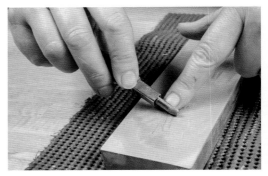

Maru-nomi (U tool): the bevel of the U tool is on a curve, but the length of the bevel should be flat end-to-end across the curve of the tool. Hold them at the angle of the bevel and sharpen. Do this either in stages across the curve, or using a figure-of-eight movement over the stone while turning the tool on its axis from side to side. Whichever way you work, ensure the tool is sharpened evenly.

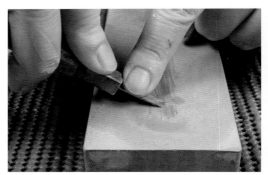

Aisuki (small chisel): less expensive aisuki often have completely square blades. You may like to round off the corners a little to make them easier to use. With the bevel in contact with the stone, slide it back and forth to sharpen normally; to round off the corners slightly, tilt it very slightly on its axis as you sharpen and the bevel will quickly start to curve. Take care not to curve the edges too far.

SUPPLIERS

UK

Great Art
41–49 Kingsland Road, London, E2 8AG
www.greatart.co.uk
General art supplies including economy Asian ply and some basic tools and papers.

Handprinted
22 Arun Business Park, Shripney Road, Bognor Regis, PO22 9SX
www.handprinted.co.uk
Specialist printing supplies; excellent selection of Japanese woodblock tools, shina ply and papers; in-depth knowledge of Japanese woodblock.

Intaglio Printmaker
9 Playhouse Court, 62 Southwark Bridge Road, London, SE1 0AT
www.intaglioprintmaker.com
Specialist printing supplies; excellent selection of Japanese woodblock tools, shina ply and papers.

John Purcell Paper
15 Rumsey Rd, London SW9 0TR
www.johnpurcell.net
Wide range of art papers including specialist printmaking papers including washi papers.

Lawrence Art Supplies
208, 212 Portland Rd, Hove BN3 5QT
www.lawrence.co.uk
General art and printmaking supplies including washi paper.

Shepherds
30 Gillingham Street, London SW1V 1HU
www.bookbinding.co.uk
Specialist paper store including washi and other printmaking papers.

USA

Graphic Chemical & Ink Co
www.graphicchemical.com
General printmaking tools and paper.

Hiromi Paper
www.hiromipaper.com
Specialist papers including washi papers.

Mcclain's Printmaking Supplies
www.imcclains.com
Specialist printmaking supplies; excellent selection of Japanese woodblock tools, shina ply and papers.

Paper Connection International
www.paperconnection.com
Specialist art papers including washi papers.

Washi Arts
www.washiarts.com
Washi paper specialist.

Japan

Awagami Paper Factory
www.awagami.com
Washi paper specialist.

Bumpodo
www.bumpodo.co.jp
Art supplies including Japanese woodblock
materials.

Karuizawa Mokuhanga School
www.mokuhanga-school.com.au
Japanese woodblock materials, tools and
papers.

Michihamono
www.michihamono.com
Printmaking tools.

Morihei
www.morihei.co.jp
Sharpening stones.

Moriki Paper
www.morikipaper.com
Washi paper specialist.

Ozu Washi
www.ozuwashi.net
Washi paper specialist.

Sekaido
www.sekaido.co.jp
General art supplies including printmaking.

Woodlike Matsumura
www.wx30.wadax.ne.jp/~woodlike-co-jp/zen4/
Japanese woodblock specialist; materials, tools
and papers.

GLOSSARY

Aisuki: chisel for cutting.

Alum: chemical for treating paper.

Ategawa: hard disc part of a baren where the inner coil is attached.

Ball-bearing baren: baren housing independently moving ball bearings, available either as a sealed unit or opening for cleaning.

Baren: disc of bamboo or plastic for burnishing the back of prints to take an impression.

Baren-kawa: replaceable bamboo sheath that covers the baren.

Baren-suji: marks intentionally left on the print by the baren.

Bench hook: wooden device intended to prevent wood from moving during cutting.

Beta baren: baren for general printing, except for delicate or line blocks where a sumi baren is preferable.

Block: the part of the wood that is cut and printed.

Bokashi: gradated shading from dark to light.

Burashi: *see* Maru bake.

Camellia oil: oil used to lubricate barens, often sold as a carrier oil for aromatherapy.

Chatter: random high points left in clearing the trench around the printed area that catch the paint and print.

Design area: space occupied by the drawing when designing a print.

Design drawing: final drawing for making a print, consisting of outlines only.

Dosa: mix of animal glue and alum for treating paper; also called size.

Dosa bake: brush for applying size/dosa to paper.

Double printing: printing the same block with the same colour on the same paper twice to increase colour intensity.

Editioning: printing a number of matching prints.

Eshi: Edo period term for a graphic designer/illustrator rather than an artist.

Gaka: Edo period term for a fine art artist.

Goma-zuri: print effect where paint appears mottled.

Hanga bake: long-handled printing brush.

Hangi-to: knife that cuts the outline of the block.

Hanshita: artist's drawing on thin paper applied to the wood as a guide for cutting the line block.

Honing: process of polishing tools to improve sharpness.

Horishi: master carver responsible for cutting line blocks.

Inking up: printmaking term for applying paint to the woodblock ready for printing.

Kara-zuri: embossing the paper using a block rather than printing in colour.

Kasure: cutting wood to mimic a brushstroke.

Kento: Japanese system of registration slots cut into the wood alongside each block.

Kento-nomi: chisel used to cut kento registration in the woodblock.

Key block: initial block cut with line detail used to print hanshita prints; usually also printed as part of the finished print.

Kira-zuri: print effect incorporating mica into the print surface.

Kyogo: prints taken from the line block and returned to the artist to add colour references.

Lapping film: abrasive film for sharpening tools.

Line block: *see* Key block.

Maru bake: shoebrush-shaped printing brush.

Maru-nomi: U gouge for cutting.

Master tracing: tracing with a complete design drawing and the margin area around it.

Mica: mineral used to give shine or glitter to the print surface.

Mizu bake: large water brush for wetting paper.

Nagura-stone: soft stone that produces a slurry of mud when wet, used with water-stones or diamond-stones for sharpening tools.

Neri: viscous, gelatinous liquid traditionally extracted from hibiscus root and used in washi papermaking.

Newsprint: cheap thin paper used in printing newspapers, sold unprinted.

Nikawa: animal glue.

Registration system: method used to make all the printing blocks line up to create a print.

Sabitsuke: *see* Kasure.

Sacrificial prints: disposable prints that precede important prints, ensuring blocks reach optimal condition.

Sankakuto: V tool for cutting.

Shark skin: dried skin from a shark; it has a rough surface used to prepare printing brushes.

Shin: the coil inside a baren.

Shina plywood: also known as Japanese or Asian ply, a soft plywood available from printmaking suppliers in various grades.

Size: mix of animal glue and alum for treating paper; also called dosa.

Sumi baren: lighterweight bamboo baren used for printing delicate detail.

Sumi ink: black pigment for printing.

Tea tree oil: essential oil sometimes used to combat mould.

Tororoaoi: hibiscus root.

Trash prints: prints taken on dry newsprint to condition a new block by pushing paint and rice into the wood fibres.

Washi: long-fibred Japanese printing paper.

INDEX

RELATED TITLES FROM CROWOOD

Making Woodblock Prints
978 1 8479 7903 2

Making Collagraph Prints
978 1 7850 0581 7

Wood Engraving and Linocutting
978 1 8612 6998 0

Making Frames
978 1 7850 0395 0

Painting Watercolours on Canvas
978 1 7850 0589 3

The Art of Chinese Brush Painting
978 1 8479 7289 7

Etching
978 1 78500 615 9

Fine Art Screenprinting
978 1 84797 9 810

Linocut for Artists
978 1 78500 1 451